James Van DerZee

The Picture-Takin' Man

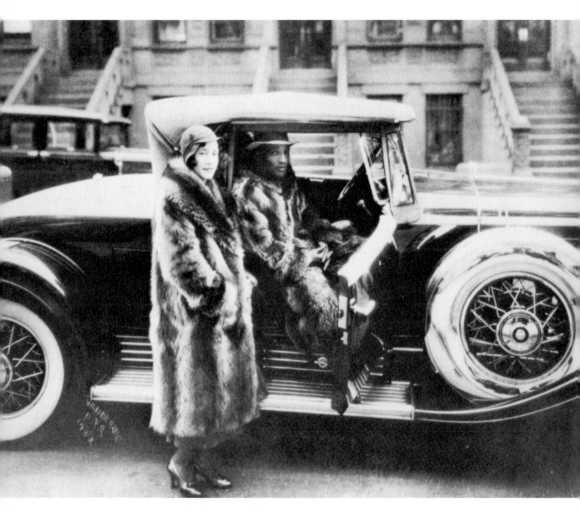

A fashionable Harlem couple, 1932.

James Van DerZee

The Picture-Takin' Man

BY JIM HASKINS

Africa World Press, Inc.

P.O. Box 1892
Trenton, New Jersey 08607

Africa World Press, Inc.
P.O. Box 1892
Trenton, NJ 08607

Cover design by Ife Nii-Owoo

Library of Congress Catalog Card Number: 91-72494

ISBN: 0–86543–260–0 Cloth
　　　 0–86543–261–9 Paper

Acknowledgments

I would like to thank the Studio Museum in Harlem and the James Van DerZee Institute for making available the photographs herein that are not from Mr. Van DerZee's or my personal collections, as well as Mr. David Dana, President of the Lenox Library Association, and Mrs. S. P. Kennard, Librarian, and Mr. Denis J. Lesieur of the Berkshire Atheneum for the information they provided. I am also grateful to J. M. Stifle, Mary Ellen Arrington, Donna Mussenden, and Kathy Benson for their invaluable help.

It would be presumptuous to thank the man who is this book—James Van DerZee.

—*Jim Haskins*

New York, 1978

ABOUT THE AUTHOR

Jim Haskins is Professor of English at the University of Florida, Gainesville, and lives in Gainesville and New York City.

He is the author of more than 80 books for adult trade and young adult audiences. Haskins has won recognition for his work in both areas. *The Story of Stevie Wonder*, a biography for young people, won the Coretta Scott King Award in 1976; his four-book *Count Your Way* Series (Arab World, China, Japan, Russia) won the Alabama Library Association Award for Best Work for Children in 1987; *Scott Joplin: The Man Who Made Ragtime* won the Ascap Deems Taylor Award for Excellence in Writing in the Field of Music in 1979; *The Cotton Club* was the inspiration for the motion picture of the same title; *Bricktop*, written with Bricktop, was named a Book-Across-The Sea by the English-speaking Union; and *Black Music in America* won the Carter G. Woodson Award in 1989.

Some other Jim Haskins books include *Mr. Bojangles: The Biography of Bill Robinson*, written with N.R. Mitgang; *Mabel Mercer: A Life*; *Queen Of The Blues: A Biography of Dinah Washington*; and *Bill Cosby: America's Most Famous Father*.

His latest books include *Hamp: An Autobiography*, written with Lionel Hampton; *The 60s Reader*, written with Kathleen Benson; and *Black Dance in America*.

He currently serves as general editor of *The Hippocrene Great Religions of the World Series*, and was General Editor of *The Filipino Nation*, a three-volume work. Formerly Vice-Director, Southeast region, of the Statue of Liberty-Ellis Island Foundation, Inc., he is currently a member of the National Education Advisory Committee of the Commission on the Bicentennial of the U.S. Constitution and a member of the Framework Development Committee of CIVITAS, a new National Civic Education Framework. The author of numerous articles, he also reviews books for *The Gainesville Sun* and other publications.

Contents

Quotes From Earlier Reviews

"The writing style is smooth, informal, and carefully researched; there are many interviews with the subject, whose memories are as interesting as his comments are colorful, at times profound."
—Bulletin of the Center for Children's Books

"Based on interviews with his subject, Jim Haskins' text has the immediacy of conversation . . . [an] engaging portrait."
—New York Times Book Review

"Haskins places [Van DerZee] in the context of photographic history."
—Kirkus Reviews

". . . exceptionally well written biography . . . [Van DerZee's] life parallels much of the black experience in America."
—Publisher's Weekly

Introduction

I met James Van DerZee in the summer of 1970 at Southampton College on Long Island. I had been invited to give a speech, and he was being honored generally for his contributions to the field of photography and specifically for his gift of some of his photographs to the college.

I had seen the "Harlem on My Mind" exhibit at the Metropolitan Museum of Art two years before and had been impressed by Mr. Van DerZee's work. I was pleased to have the opportunity to meet and talk with him that afternoon. He was a delightful person, warm and friendly, with a wonderful sense of humor.

The next week I visited him at his apartment on West Ninety-fourth Street in Manhattan, and on occasion during the next few years he would call or write, and I would call or stop by to give him a book and talk. I acquired some of his photographs for my personal collection, and on one occasion I was privileged to have him photograph me for book jackets.

JAMES VAN DERZEE

Three books devoted to his work have been published, one by Grove Press and two by Morgan and Morgan. They are excellent chronicles of the range of his technique and subject matter, but text in each is minimal, little more than a brief sketch of his life and ideas. Having gotten to know James Van DerZee, I felt he had something to offer besides his photographs.

Here was a man who had lived nearly a century. He had seen photography advance from a primitive process to a highly developed science and a true art form, both. He could remember when color photography was impossible, when a picture was spoiled if the subject moved, when things that are invisible to the naked eye were also invisible to the camera's eye. He had taken up photography at a time when the photograph and the camera were comparatively rare items and lived to see a time when visual images are perhaps the chief means of communication in the modern world. He had seen more American history and black American history than most of us ever will. He had lived through two world wars and the Depression between. He had seen Harlem change from a suburb built for the wealthy to a well-kept black community, to a teeming, riot-torn slum. He had seen Marcus Garvey organize his black nationalist movement, observed the religious movements of Father Divine and Daddy Grace, experienced the results of the unkept promises of the Civil Rights movement. His life had spanned the development of the phonograph, television, the automobile, the airplane, and the demise of the ten-cent hotdog, the summer straw hat, and the "Colored Only" want ad. Through the eye of his camera, he had amassed a valuable pictorial record for posterity, but he had seen and experienced many things that he had not photographed. He had also enjoyed the rare good fortune to love as deeply as it is

INTRODUCTION

possible for a human being to love. It seemed to me that James Van DerZee also had a story to tell in words.

Just as he went about making his photographs, unaware of many of the aesthetic controversies in the field of photography, so he went about living, with little interest in the philosophical and political controversies that often raged in the world around him. He has never pretended that his advanced years give him claim to profound historical understanding, and yet through James Van DerZee's story, the reader will gain insights about life in America in this century, and in part of the last, too. And the reader will learn as well what it has been like to be a black man who, except for a brief, tragic period—a period in which he was hurt not because he was black so much as because he was old—has lived his life in quiet dignity.

Here, then, is the story, garnered from personal interviews, of James Van DerZee, the picture-takin' man.

1

How It All Began

In 1968, the Metropolitan Museum of Art in New York City opened a show called "Harlem on My Mind." It was both a chronicle of the history of Harlem and a celebration of the contributions of black people to New York City and the nation at large. A huge exhibit, it would be the subject of much controversy. Some people felt it glossed over the discrimination and segregation the people of Harlem had suffered ever since it had become a predominantly black community. Other people felt it did not give enough coverage to present-day Harlem. It was rare to find two people who agreed on any aspect of the show except for one: for the first time, "Harlem on My Mind" brought to the general public view the photographs of James Van DerZee.

To people who were used to seeing only photographs of Harlem's slums or the whites-only nightclubs that once flourished there, Van DerZee's pictures of neat, well-furnished homes and

stores were a new visual experience. To people who had never seen anything but portraits of famous blacks and pictures of poor, downtrodden Harlemites, his photographs of black families in Easter outfits, beautiful children, and handsome men and women were a revelation. James Van DerZee's photographs showed that ever since Harlem had become a black population center, there had existed an "other Harlem," where people worked hard and loved their children and managed to lead lives of comfort and dignity despite the hostility and neglect of the white world outside.

Not only were his photographs important as historical documents, they were also valuable as works of art. Far more than mere snapshots, most of them were clearly products of careful study, painstaking production, and great compassion—the creations of a true artist. What's more, that artist, whom hardly anyone had ever heard of before, was still alive and living in New York City. James Van DerZee was "discovered" when he was eighty-three years old!

He was a remarkable man, and not merely because of his photographs or because he had lived longer than the majority of us will. He had a better memory than most men half his age, and a finer sense of humor. He was also a delightful storyteller, and much of the story that follows is told in his own words.

"At the time I was born, why, Grover Cleveland was President. And that was way back at the time when France sent that Statue of Liberty over to be placed in the New York Harbor, back in 1886," mused James Van DerZee one hot summer day in 1976 as he sat in his small, cramped New York City apartment. He did not actually remember the dedication ceremony over which President Cleveland presided on October 28, 1886, for he was only

four months old at that time, but he remembers that his family talked about the event for years afterward. It was an important occasion for all Americans, but it was particularly special to James's parents, for they had once been New Yorkers, and members of a former President's household at that.

John and Susan Elizabeth Van DerZee had served as butler and maid in the home of Ulysses S. Grant in New York City. The former President and his wife had moved to New York in 1880 to be near their son, Ulysses, Jr. The younger Grant was a partner in the investment firm of Grant and Ward, and his father put his considerable fortune at the disposal of the firm. The Grants rented the residence of ex-U.S. Senator Jerome B. Chaffee on East Fifty-second Street when they first came to the city, then moved to more permanent quarters at 3 East Sixty-sixth Street in 1882 or 1883. The Van DerZees joined the Grant household at this address and left their posts in late 1884 or early 1885. Apparently, they never said very much about their period of service there, for, according to James Van DerZee, "by the time Grant meant anything to me, I only knew what I learned about him in school; he was one of the Presidents of the United States."

James always figured his parents had left Grant's employ because they were expecting their first child. It is more likely that the Van DerZees left when the Grant fortunes were reversed, and that they were simply discreet about their recollections of the former President's household, in the manner of well-bred servants who respected their employers and did not care to pass on tales of misfortune. In 1884, the firm of Grant and Ward collapsed, swindled by Ulysses, Jr.'s partner, Ferdinand Ward. The Grant fortune went with it. Although the effort by the firm's creditors to hold the former President personally liable was unsuccessful, to

satisfy them he surrendered all his property. John and Susan Elizabeth were let go, along with other servants. Once out of the Grant household, they could have gossiped about the effects of financial ruin on the proud family. It is to their credit that James would think of U.S. Grant only in the most impersonal way: "A guy came in the other day and paid me for some pictures, and I look at the bills and I say, 'There's my mother's old boss!' "

John and Susan Van DerZee left New York and traveled to Lenox, Massachusetts, a small town nestled in the Berkshires not far from Pittsfield. Relatives had moved there long before.

Settled around 1750 and originally called Yokuntown, Lenox had been set off from the town of Richmond in 1767 and renamed, probably after Charles Lennox, Duke of Richmond and a defender of colonial rights. When the town was incorporated in 1775, it was little more than a group of white clapboard houses surrounded by freshly painted picket fences along the Pittsfield Road. The townfolk were excellent gardeners. They supported themselves primarily by potato farming. While the men put in their long days' work in the potato fields, the women kept neatly tended vegetable and flower gardens in their yards. As the town grew, as streets were laid out from the Pittsfield Road, and as more neat houses were built along these streets, Lenox retained its sense of order and quiet. It had about it a peace and unchangeability that led one writer to note early in this century, "Lenox . . . seems to have the air of having always 'been.' "

This peace and calm, as well as numerous brooks and two nearby lakes, Stockbridge Bowl, or Lake Mackeenac, and Laurel Lake, attracted a number of writers to Lenox in the middle of the nineteenth century. They built their small cottages and visited

back and forth. Fanny Kemble gave Lenox its first social atmosphere. The famous actress, divorcée, and skilled horsewoman enlivened the sleepy town, it is said. But she was only one of several well-known people to spend time in Lenox. Catharine Sedgwick, a novelist, and Henry Ward Beecher, an influential spokesman for the Protestant Church, lived there for a while, as did Nathaniel Hawthorne. He wrote *The House of the Seven Gables* in his cottage there in 1850–1851, as well as *Tanglewood Tales*. Thereafter, Lenox was sometimes called Tanglewood, a name that became an official appellation in the music world after the Boston Symphony Orchestra began to make Lenox its summer home. Later on, in the early twentieth century, the author Edith Wharton would spend June to December in Lenox, recalling in old-timers' minds the years when the town was a writers' colony.

The primary industry in Lenox was mining, and the earth under the town is still a maze of mine shafts. According to a story favored by the local people, a maid once went to draw water from her mistress's well, and when her bucket came up empty, looked into the well to see a miner in a headlight hat walking by. Another local tradition holds that armor and guns for the Union *Monitor*, John Ericsson's famous "cheesebox on a raft" that engaged in battle with the Confederate *Merrimac* in 1862, were made from iron mined and smelted in Lenox and Richmond.

After the Civil War, another industry attempted to establish itself in Lenox. Founded in 1869, the Lenox Glass Company started running into problems as soon as it was in operation. Lenox was too far away from the large cities to enable the company to fill orders quickly, and so distant from major shipping arteries, like the Atlantic Ocean and the Connecticut and Hudson rivers, that shipping costs were prohibitive. Unlike the rocks and

ores from the quarries, the fragile product of the Lenox Glass Company required careful and costly packing in order to be shipped by wagon or rail. The Lenox Glass Company closed in 1872, and its experience caused other industries that had considered locating in Lenox to reconsider.

Less than a decade later, the former farming town, former writers' colony, and failed industrial town became a major resort. Though its lakes and brooks and breathtaking mountain scenery had long had their aficionados, before 1875 Lenox had not been an "in" place for high society. Now, partly because of its scenery unspoiled by industrial progress, perhaps partly because of the influence of Edith Wharton's family, the Newbolds, and partly by chance, some of the wealthiest families of New York and Boston —the Schermerhorns, the Hegemans, the Schieffels—chose Lenox as the site of their fall "season."

These wealthy people never spent the hot months in cities. In that age before air conditioning, even their palatial town houses were unbearably hot, humid places. So, in the summer they went to seaside resort towns like Newport, Rhode Island, where the ocean breezes cooled the air, and in the fall they traveled to inland New England towns, where the multicolored foliage was most beautiful. In Lenox, they built country houses on the lanes branching out from the Pittsfield Road and came in droves to spend September and October in a round of teas, dinners, and dances. It was a short season, so the social activity was quite frenzied; and then, apparently, the society dames and dons decided that Lenox would be a nice town in which to spend the summer as well. After all, Newport was not the only place to go in summer.

They began to build grander houses, ornate monoliths of wood and stone, surrounded by acres of landscaped woods and lawns.

JAMES VAN DERZEE

They occupied the land by the country lanes that bisected the Pittsfield Road, and graced the shores of Laurel Lake and Stockbridge Bowl. (Sadly, none of the most pretentious structures has survived.) By 1880, prime country farm land was selling for $3,000 an acre. A town whose assessed valuation was $1,599,411 in 1885, was assessed at $3,750,004 seven years later. The quiet little town was transformed in the warm months when the summer people had their balls, their teas, their charitable events, their "Flower Parade." By the time John and Susan Van DerZee arrived, Lenox in season was wealthy and grand.

James Van DerZee would remember, "All the rich people would come there in the summer, with twenty-five to thirty people to help: butler, coachman, gardener, four or five housemaids, a laundress, a cook . . . and they would need it in those big homes that they had. After Roosevelt took over—I don't know what it was all about—they weren't able to have those big houses."

When they came, the summer people swelled by several hundred the town's population which, in the off-season, numbered only eight or nine hundred people. Unlike the writers who had come before and who respected or even admired the local people for their simple New England integrity, many of the wealthy people tended to look down upon the townspeople as crude rustics. A man who recalled the days when Lenox was a fashionable resort town said in 1965, "I remember it, but I don't resent it. Some did and some still do. It was the way things were here. You were either rich and lived in one of the big houses, or you lived in town and waited on them . . . Some were pleasant. They'd speak and pass the time of day. Others would snub you. But you never forgot that they had the money and that your living depended on them."

HOW IT ALL BEGAN

Among the Lenox townfolk were about half a dozen black families, including the extended family that James Van DerZee's mother and father joined midway through Lenox's transition.

John and Susan Van DerZee moved into a white frame house on Taconic Street next door on the one side to David and Josephine Osterhout and on the other side to Fanny and Lena Egbert, forming a sort of family compound. "We were all together, three little houses together. There was my aunts' house, our house, and my grandparents' house. We had a stable and my grandparents had a stable, and they had a henhouse and we had a henhouse."

Everyone worked, in one way or another, for the white people. David Osterhout, James's grandfather, was sexton of the Congregational Church, often called "the church on the hill." James's grandmother, Josephine Osterhout, ran a laundry business with her four Osterhout daughters, Estelle and Mattie, and twins Emma and Alice. "They had a very large laundry. A great many of the wealthy people would send their laundry from the Curtis Hotel and even up from the city by horse-drawn carriages. The chauffeurs would bring up trunks and hampers of clothes and they would be hand-washed and starched. We would have to get the water to wash them from the brook. And then we would load the clothes into the wheelbarrow and take them out to be hung up in the meadows. And they would come back smelling very sweet, with odors of the pines. If you went into the house smoking, my aunts would have a fit, afraid that the odor would get into the clothes." Two of the daughters were also dressmakers. The one Osterhout son, David, worked as a chauffeur for wealthy visitors.

James's great-aunts, Fanny and Lena Egbert, were apparently sisters-in-law to Josephine Osterhout, who had first been married to a man named Egbert. James's mother, Susan Egbert, had been

born of that union. The four Osterhout girls were, in Van Der-
Zee's words, "part-sisters to my mother." Such familial relation-
ships did not concern him at the time and continued not to. "I
don't know who it should concern more than me and *I* don't know
quite how it all came about."

The Egbert sisters operated a home bakery, for there were no
bake shops in Lenox at the time. "My aunts used to make all the
bread used by the Trinity [Episcopal] Church for communion,
and they served bread and cakes to the very wealthy people. I
remember there were a great many people that we used to deliver
cake and bread and pies to. They even made ice cream for various
people, and my brother and I were always anxious to get at that
dasher when they pulled it out of the freezer. They had to pack
the ice cream in ice and salt to keep it cold and hard, and my
father would use the horse and wagon to deliver it."

James never knew his paternal grandparents or most of his
other relatives on his father's side. He was given pages from a
family record wherein were noted Van DerZee births, marriages,
and deaths from 1837 to 1867, beginning with the entry: "Thomas
Vanderzee was marid To miss Sarahann Tunistan January the 20
in year 1837 In the Viledge of Newbaltimore, Greencounty," and
including nine entries of the deaths of persons, most of whom
were in their twenties and none of whom was older than forty-
nine. Though the family had originated in New Baltimore, New
York, some had moved to Topeka, Kansas, and some had even
reached California. James was told that his paternal grand-
parents' names were John and Josephine Van DerZee and that his
Uncle William, who became a preacher in Kansas, wrote poetry.
He visited a Jennie Van DerZee in New Baltimore once, on a trip
to New York, but his memories of her are sketchy. "There are a

great many questions I would have asked my father if I'd ever thought that things would have turned out as they did."

He would, for example, have asked about the origin of his surname. According to James Van DerZee, there are only a few hundred people in the United States who bear that name, a situation that holds both advantages and disadvantages. "It's a good name to have if you've got good credit. If you haven't got good credit you're pretty easily traced down and located."

In 1977, James Van DerZee received a letter from a woman in Canada who had seen his photograph in an article on Harlem that appeared in the February, 1977, issue of *National Geographic*. Her grandmother's name was Van der Zee, she wrote, and this was the story she had heard about the origin of the name. Many years ago a ship was wrecked off the coast of Holland and the only survivors were a group of children who were too young to know their names. No one could tell where they came from and it was impossible to return them to their families or relatives. So the children remained in Holland, and because of the circumstances of their discovery, they were all given the last name Van der Zee, which is Dutch for "by the sea. Hearing the story, James Van DerZee wondered if one of his ancestors might have been the "black diamond," as he put it, in that group of children.

The slightly different spelling of the name did not bother him. His own name has gone through several changes of spacing and capitalization over the years. His business cards have introduced him as "Van Der Zee" and he often signed his photographs "Vanderzee." He now prefers Van DerZee and signs his name that way, so that is the way the name is used here throughout.

2

Growing Up in Lenox

James's older sister, Jennie, was born in Lenox in 1885. The next year, on June 29, 1886, James Augustus Joseph Van DerZee was born. At the time, John Van DerZee was helping his wife's aunts in their bakery business; he is listed as a baker on James's birth certificate. Soon, however, he would be hired as sexton of Trinity Church, the Episcopal Church in Lenox. As early as James can remember, his father was a church sexton, and James would spend much of his time helping his father with his work around that church.

The Episcopal parish in Lenox goes back a long time and may have begun as early as 1763, but over the decades other churches, particularly the Congregational Church, which was built in 1806, were more successful in attracting worshipers. Trinity Church declined. The Board of Missions reported in 1850 that it had become the weakest parish in the town and had been without a formal schedule of services for four years. Parishioners were so

few that they could hardly pay a minister's salary. The Reverend William H. Brooks, who arrived in 1855, was paid a salary of eight hundred dollars a year, five hundred of which was furnished by a wealthy man named Aspinwall.

Trinity parish benefited from Lenox's boom as a summer resort, for many of the summer people were Episcopalians, among them, according to James Van DerZee, the Vanderbilts, the Morgans, and Westinghouses, and Sloanes, the Bishops, and the Danas. They felt that their church should be somewhat grander than the original, unpretentious frame sanctuary, so a new stone church was planned. The new chapel was financed by one of the summer people, a lawyer named John E. Parsons, in memory of his daughter, Helen Reed Parsons, who had taken sick and died while on a visit to the South. The cornerstone was laid September 8, 1885, and the structure was dedicated in July, 1893. It was a grand building, the talk of Lenox and surrounding towns. The Pittsfield *Sun* kept its readers apprised of the final stages of the new Trinity Church. April 27, 1893: "The chapel is built of grey stone . . . the interior walls are buff brick, the woodwork, oak. A five-hundred-pound bell has arrived . . ." June 8, 1893: "The pews of solid oak are in place, and the chapel will seat two hundred people. The handsome Tiffany windows are in. . . . The oak lectern, chancel lamp of solid brass and chancel chairs have arrived . . . Several valuable gifts have been received, a font and solid communion service."

James Van DerZee would remember when "the Sloane people in New York, the rug people, presented the church with a twenty-five thousand dollar rug. It had taken about five or six people to carry it; a very huge rug, brought over here from the other side [Europe]."

JAMES VAN DERZEE

As sexton, John Van DerZee was responsible for maintaining the church and rectory and the grounds, not an inconsiderable task. There was brass to be polished, aisles to be swept, woodwork to be dusted, lawns to be mowed, snow to be shoveled in winter. Some of the work was unpleasant. Periodically, the coal furnaces had to be emptied of ashes. "You'd have to take the ashes out down in a low-ceilinged basement and you'd inhale a lot of dust from the ashes. I used to hear Mother telling him lots of times to put cotton in his nose. But he found it too much bother to do that, so sometimes he'd wet the ashes and make them soggy and heavy."

Still, John Van DerZee's job as a sexton provided a steady income, which he supplemented by odd jobs on the estates of the wealthy. "There were all those big lawns." He needed all the money he could earn to support his growing family.

One year after James was born, Walter arrived, and thereafter Charles, Johnny, and Mary. Johnny died of pneumonia, October 28, 1896, at the age of six, and James would have only the barest recollection of him.

A growing family also required a larger house. "We had four bedrooms upstairs, and a bathroom, and an attic above that. And on the floor below there was a double parlor, and a dining room. And later on, my father built an addition, and we had a big billiard-pool room. He also put in a fireplace. And then he put a porch around the whole place. Made quite a nice place of it."

John Van DerZee was the central figure in the household, and James would always regard his father as a major influence. "It was a very peaceful family. My father was very gentle, but he was at the head, and my mother and all of us kids respected him.

GROWING UP IN LENOX

"I never heard my father speak a cross word but once or twice in my life, and he had occasion for that. I was kind of a mischievous guy. I only remember one time that my father was a little tight on us. He sent my brother Walter and me to put the cow out to pasture, to move her to fresh grass. There was a very fine apple tree up there, and my brother and I were busy gathering these apples—kinda lost track of the amount of time we were spending up there. Father came out to look for us, wanting to know why we were gone so long, and he ran us back home."

James would always associate the aroma of cigars with his father. "On occasion he would smoke a Cuban cigar. You could smell it long, and never see him. You wouldn't even see the smoke, just smell the aroma and know that he'd been there."

A slim man who wore a wide moustache most of his adult life, John Van DerZee posed with James, Walter, and Charles in Lenox around 1909. His face is kind, reflective, and tired. He had worked hard to support his family and was proud of his three sons.

A photograph of the Van DerZee women, also taken in Lenox around 1909, shows a strong-faced woman whose quizzical expression indicates a dry wit and whose ample body testifies to her years in the kitchen. At the time of the photograph, Susan Van DerZee had raised five children and seen two of them married. Her family had remained close despite illness and economic hardship. Her life as a black woman had not been easy, but she had managed well, and she would live to advanced age in relative comfort among those she loved.

Most of James's early memories of his mother place her in the kitchen—"She cooked everything. Everything tasted good to me in those days and I always wanted plenty of it."—or hovering

over the family at Christmastime. "Christmas, we always got something. I don't know how Mother arranged it, to hide so many presents for us all, and we didn't know anything about it until the night before Christmas."

James learned about astronomy and weather from his mother. "She seemed to know all about all the different stars and planets. She knew the evening star from the morning star, Mercury from Venus, the Big Dipper and all that sort of thing. She could always tell by the sunset what the next day was going to be like. Used to have a bottle of alcohol with camphor in it for a barometer. At times it would be clear; other times it would seem to be thick on the bottom.

"She was a very quiet and gentle woman, but she was strong. I was always guided by her influence. A wealthy lady told me one time, 'Jimmy, your mother's a very smart woman.' "

As soon as they were old enough, the children were expected to share in the family work. While the girls helped with the household chores, James and his brothers assisted their father at the church. They swept the aisles, polished the brass, and dusted the pews, mowed the lawns and raked the leaves; and since their father's duties included grave-digging, they also helped him do that. The task often unearthed interesting mementos. "Lots of times, in digging those graves, he would pick up so many of the old Indian arrowheads, stones, and bones. Then I could picture the Indians riding over the same land a hundred years before."

James's imagination was also piqued by some of the more grisly findings in the graves. "Sometimes we'd have to dig up the old bodies and remove them. Some of them . . . why, their hair had grown down over the face and the nails had grown long. Nails and hair continue to grow after death, but some of them had even

changed position in the caskets, indicating that they may have been buried alive."

At home, "we helped our father chop down trees, saw wood for the fireplace. In the fall of the year we watched until the chestnuts were just right, and we'd pick up a big stone and hit the tree, and a rain of chestnuts would come down. I think that is my fondest memory. We'd roast them. In the spring we'd go dig up dandelions and get the dandelion greens. My aunt used to make wine. We never made wine.

"We used to help Father plant things in the garden. We needed a big garden because there were so many of us children. We had cows and horses and chickens. We grew up knowing a little bit about everything, how you put the seeds in the ground, how in a few days you go out there and look and see a little sprout coming up. You nourish it, you rake the dirt up around the roots, and each day you see the corn and beans and all the different things grow a little bit more.

"There was only one job I really didn't like and that was shoveling snow. In those days the snow really came down! My father had a snow plow and he would open up all the paths around, and my brother Walter and I would have to do a lot of shoveling. I figure I did enough shoveling to last the rest of my life."

James does not remember any quarrels, or sibling rivalry, or any economic hardship in those early years. There was always plenty of wood for the fire in winter, plenty of food on the table at mealtimes. The children learned early to be happy with what they had. Presents at birthdays and on Christmas were not lavish, but, as James put it, "I knew what was in the possibilities of getting, and what wasn't." It was a happy household, a simple life that revolved around hard work and the church, good food and

simple pleasures. The Van DerZees, Osterhouts, and Egberts were a close family, and on days when they were not working, they engaged in religious and social activities together.

"On Sundays, my grandfather would always have what they'd call Prayer Meeting. We'd all get together and have a prayer meeting at our house, or we'd go to their house. I spent so many years in church and at Sunday school and at those prayer meetings . . . I don't know as I would call myself a religious person, but all that kind of grows on you, becomes part of you."

When visitors came, it was always a special occasion. One visitor was particularly special, although at the time no one knew how important he would become. "DuBois used to come up and visit my grandparents' house. [W.E.B. DuBois, a native of nearby Great Barrington, Massachusetts, was probably attending Harvard at the time. He would become an important black leader.] I was quite a kid then. They had the four girls up there, and they were an attraction to him at that time. But he didn't marry any of them. In fact, none of them ever got married. Of all my grandparents' children, only two got married, my mother and the one brother."

What James liked least about Sundays in Lenox was having to dress up. "Those wide, stiff collars! After a while we got the sailor blouse, the knickerbockers, knee socks." To the best of her ability, Susan Van DerZee always saw to it that her children were clean and neatly attired for church, Sunday visitors, and school.

There was plenty of time left over for play. There were the meadows to roam and the woods to explore, and important items to acquire. At one time, James went to considerable effort to make a bicycle. "I managed to get as far as the front wheel and the handles, but all that other part I couldn't seem to figure out.

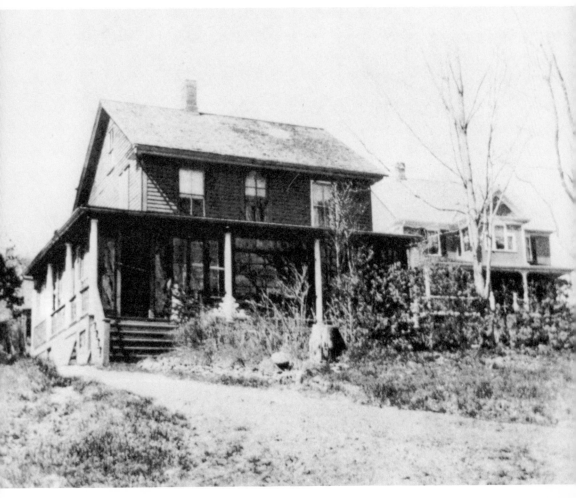

The Van DerZee home. James's bedroom window is at upper left. To the right is his grandparents' house.

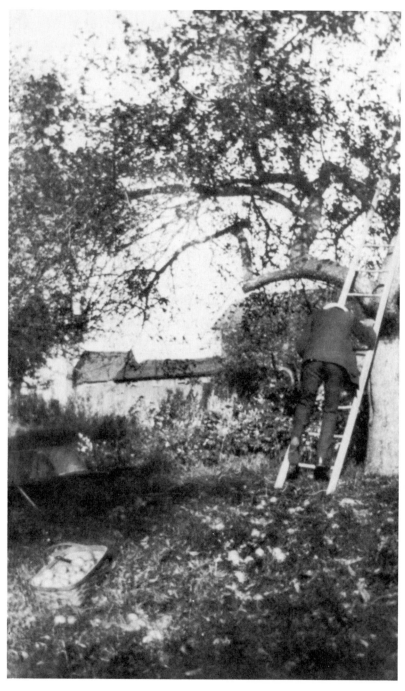

John Van DerZee climbs down from the apple tree that his sons thought was so "fine."

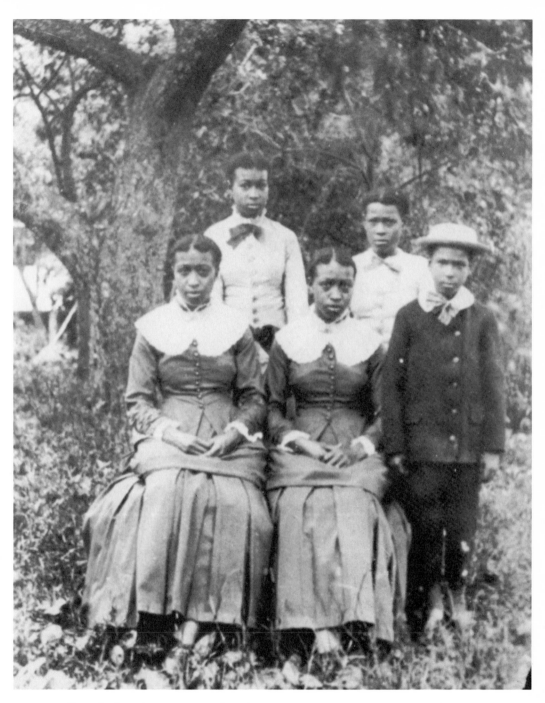

James's Osterhout aunts and uncle. Mattie, Estelle, and David, standing (*left to right*). Emma and Alice, sitting. This photograph was copied from a tintype made before James was born.

James and Walter, around 1900.

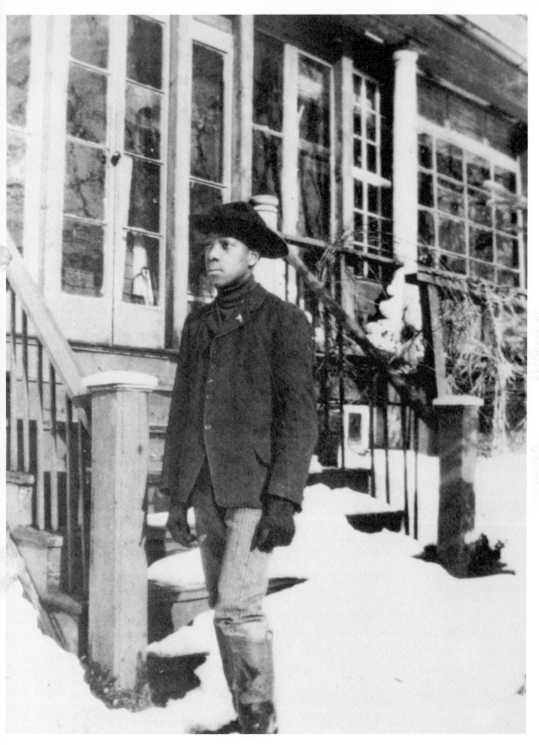

James, age 14, in Lenox.

JAMES VAN DERZEE

Before I figured it all out I managed to get one. I think it cost about eight or nine dollars. But then they had the old inner tubes, and the tires could easily get punctured. And it wasn't long before that was traded in, and I got a little better one. And I was all set! Oh, if you didn't have a bicycle, why that was a sentence right there, a crime. All the kids wanted bicycles, would do almost anything to get one.

"Then there was the time when I was interested in telescopes. I remember that a surveyor came by, and on his surveying instrument was a telescope. He left it in the barn overnight, and I tried to figure out how I could get the telescope off there without anybody knowing. But I was the biggest kid in the family, and I knew I couldn't get away with it, so all I could do was take it out and peek through it and put it back. He came back for it the next day. Later on I did save up enough money to buy a telescope, and it had a celestial eyepiece and a terrestrial eyepiece . . . Isn't that some feat they've just accomplished, putting that Viking on Mars? You can't imagine the amount of brains . . ."

The adults had time for pleasure too. "They all liked to fish. My mother's aunts and my uncle used to sit by the river all night long and fish. My grandfather and my uncle were great fishers. We'd go in the springtime and in the winter, cut a hole through the ice. My grandfather did a great deal of hunting, but my father didn't. Sometimes my brother and I would go hunting with my grandfather. One time I shot a little squirrel, and when I picked him up he seemed to have nuts in his mouth, and I had an idea he was taking those nuts home to his babies. I felt kind of ashamed of myself for having shot him and got so I didn't see much pleasure in hunting, other than target practice. Sometimes we'd kill the frogs in the brook and have frog legs for dinner.

"Swam in the brook, too. One part of it was quite deep and we used to wade around and paddle in it. The lake was too far. Our parents were afraid to let us go out to the distant places. There was a golf club out there, and we were very anxious to caddy for the club, but we were never able to do it."

They were too far away from the club for their parents to allow them to try for caddy jobs, but even if they had lived closer to the club, it is unlikely that the Van DerZee boys would have been hired. Lenox, Massachusetts, was a relatively benign environment for blacks, but they had to keep their place; and the black adults, being older and wiser in the ways of small town New England society, were very protective of their children, managing thereby to avoid most unpleasant incidents.

Lenox was a small community and positions were well defined. The Van DerZees and Osterhouts and Egberts occupied service positions that were needed and thus respected. When the two races did come together under circumstances having nothing to do with employment, they were in situations where discrimination was not supposed to show. Everyone attended church socials and went to the few traveling entertainment shows that came to town, and when the wealthy people came, they generally treated the local people, black or white, the same. "Why, they'd take a whole class of children and invite them out to their great big houses. Some would have as many as seventy-five rooms, and we'd play hide-and-seek all through the place. They'd take us on hayrides and boat rides on Laurel Lake or on the Housatonic River."

Over the years, James formed certain opinions about those wealthy people. To begin with, he figured that some of them must have become rich because they were very stingy, like "Mr. J.P.

JAMES VAN DERZEE

Morgan . . . We were there delivering some bread—cake or something my aunt had made—and my brother and I were sitting on the seat of the wagon. The gardener came out and gave my brother and me one of the peaches from the orchard. They were the sweetest, most tender peaches, but he said he could only give us one each. My brother and I then begin figuring out how we can get over that fence for some more. But the gardener says, 'The old man counts them peaches. He knows just how many he's got.' He told us that, I guess, to throw a scare in us. Yeah, that was J.P. Morgan."

The daughters and young wives of the wealthy seemed uniformly pretty and nice—and idle. In the summer when they came to Lenox, they would teach Sunday school. "I remember one of the Sunday school teachers was Miss Constance Parsons, another daughter of John E. Parsons. He was a very important lawyer." They would also offer special classes in music and the domestic arts at the Town Hall. And they organized and presented the annual Flower Parade. "One young lady used to arrange the flowers on the altar for the different churches. They had these big gardens and hothouses and so many flowers; they would furnish them for the churches. One time this particular lady was arranging flowers in a vase and she gave me some flowers to hold, and she had the *softest hands*. She didn't do any work, that's why they were so soft. They had a maid, governess; and her hands were *so soft* as she took those flowers out of my hand."

The wealthy people were so different from the Lenox natives that James hardly considered them when he pondered relations between blacks and whites.

On entering school, the Van DerZee children became aware that, as blacks, they constituted a very small percentage of the

population, although the larger white population was by no means ethnically homogenous. James went to school with Irish, Canadian, and Scottish children, and the children of the Italians who worked the stone quarries and made crushed rock for roads in those days before automobiles. "I never heard about any Jews in Lenox." But he would remember the remark of a wealthy woman with a big garden whom he and his brother used to help. "She said to me one time, 'Jimmy, it's terrible down in New York now. You know, the Jews even go to the Waldorf Astoria.' Well, I didn't even know about Jews. I knew there were all the nationalities—I knew they all existed. As long as they treated me all right, I treated them all right. Years afterward, I remember thinking, 'She ought to go to the Waldorf Astoria now!' "

In school, the Van DerZee children were often the only black children in the class, although sometimes one of the Adams or Crockett children would be in the class, too. But James did not encounter any obvious discrimination or prejudice. "There was no way there could be, because the only things we [blacks and whites] did together was go to school and to church."

Nevertheless James had "a certain feeling of inferiority. And I guess that was due to there only being about six or seven colored families there in Lenox, scattered around, and that was it. We knew we looked different from the others, and a lot of the kids didn't understand that we weren't black by choice. They didn't understand that nature has made certain people different because of different climates." Only one incident remained vivid in his memory.

"We were going to have a geography lesson, and I looked in the book and it said something like, 'Africa is the hottest of all continents, it's the home of the Negro, or black race. They are known

by their thick lips and kinky hair.' And I didn't think I wanted to be present at school when that came up. So my brother and I thought we'd take a walk to Pittsfield that day. Just our luck, they didn't have the lesson that day but the day after. One or two of the kids looked back at us because they felt we were the nearest to Africans. Some of the kids knew we weren't. They understood because they'd seen real Africans. Their parents were quite wealthy people who used to travel around a great deal. It made it easier for them in geography to remember the difference between an island and a peninsula, what a strait was, because they had seen all that."

James did not particularly like school. "Somehow or another, I didn't like studying too much, too much brain work." But he liked and respected his teachers, especially a woman named Miss Downs. He can remember being punished only once, for an infraction he has forgotten, and that was by Miss Downs. He enjoyed reading and believes he learned to read before he entered school. "I guess I was so anxious to read that I learned early. My aunts used to tell us stories, as the twilight came on, about the Indians, and we would imagine we saw their camp fires burning . . . And there was the library in town, and we used to be able to get quite a number of books. I remember one of my favorite books was *Jimmy Boy*. It told how the different pots and pans talked to each other."

These preschool experiences—hearing his aunt's stories and reading library books—encouraged what was probably a naturally lively imagination. When James was seven or eight, there occurred the first of two instances in his life when he saw "something that wasn't there." He and some other children were play-

ing a game of jump rope when all of a sudden, "I saw a little imp, smoke all around his feet, coming up under the rope. Looked like a little stuffed doll we had at one time. Nobody saw it but me, but I saw it. I began hollering, trying to tell them what I saw, but nobody believed me. They didn't know what to think, but they knew by the way I was carrying on there must have been something wrong!"

In school, he enjoyed reading poetry because it excited his imagination. Remarkably, for the rest of his life he remembered verbatim some of the poems he had to learn, among them "The Village Blacksmith" and Thomas Gray's "Elegy in a Country Churchyard." "I had a great many favorite poems, mostly ones that were descriptive. Some of the poems, why, they would put pictures in your mind and you could practically see a picture."

The only time his excellent memory seems to have failed him was when the school had a play and James, age nine or ten at the time, was cast in the role of a vagabond. "I remember I had to recite about a dozen words—'Though the road is rough and stony and branches off in many directions . . .' Something like that. I couldn't remember it half the time. I'd get so excited being up there, I'd get it all mixed up."

Both James and his sister Jennie excelled in forms of imaginative expression. "She'd play the opening song at the beginning of the school day and the closing at the end. There was a pipe organ, and some of the boys would pump it, and she would sit up there with her little legs hanging down, playing 'Now the day is over, night is drawing near, shadows of the eveningtime steal across the sky.' Every graduation, we always knew who was going to be head of the class. Music and art, music and art, James and Jennie,

James and Jennie. But we never considered that *anything*, just happened to be our luck."

Although Jennie was a more talented musician than James, he had considerable talent himself. "We had a square piano at home and I just kind of taught myself on it. I don't remember when or how I learned to read music. When you're born with a certain amount of it in you, you don't know when you start." He also learned to play the violin. In school, a man named Professor Monroe would visit once a week to give musical instruction, but James feels he was largely self-taught on both instruments.

James was far more interested in music and art than he was, for example, in sports. Although he was strong and healthy and not afraid of work, he simply preferred these activities. "One time I was playing ball and the ball hit me on the end of my fingers, and I decided ball and music didn't go very well together."

The whole family was musically and artistically inclined. "There were many fine musicians among my ancestors. There was one boy who was a very fine pianist. Once, some people went over to Europe, and they found a piano in Germany that they liked very much, so they brought it back to America. But the trip over on the boat somewhat changed the tone of the piano. They gave it to my aunts, and afterwards it was turned over to my mother's aunts, my great-aunts."

His four aunts formed a "singing quartet," and one of them taught music as well. His grandmother and great-aunts played guitar, and his uncle played the fiddle. "My father played accordion and his favorite song was 'The Mockingbird.' He'd always tell us to play 'The Mockingbird.'"

According to James, there were not many musical events in the town, so if people wanted music they pretty much had to make it

for themselves. "There were no orchestras. There was a town band, and they did a little parading on Decoration [Veterans] Day. My grandfather had served in the Civil War and he used to dress up in his uniform on Decoration Day, until it eventually became too small for him."

At other times, they would listen to the gramophone. "My aunts had an old music box and when gramophones came along—the ones with the horn that played the round disc records—my grandfather got one. Put out by Edison, I think it was. And I always remember one or two songs that were played on it—comical little records. One went like this:

> 'Twas just a year ago today I took to me a wife
> And ever since she's proved to be the burden of my life. . . .

"Then there was another one, 'Cohen on the Telephone':

> Mr. Cohen talking to the landlord: Send down the car-*pen*-tah.
> Landlord says: The painter?
> Mr. Cohen: No, I did not say the *paintah*. I said the car-*pen*-tah. Last night the wind came and blew off my shuttah and I want the car-*pen*-tah to put it on.
> Landlord: Did you say shut up?
> Mr. Cohen: No, I did not say shut up. I said, my *shuttah*. Oh, nevah mind. I will do it myself!

Often, during the long winter hours, members of the family would sit around drawing and painting. The impetus for such activity apparently came from John Van DerZee who, according to James, was an excellent painter. Jennie proved to be a talented

artist. "Teacher would give her a chair to stand on, and she'd decorate the blackboards all around the school. And there was a wealthy lady, Miss Kate Carey, whose mother was an invalid, and she'd pay my sister to go there and draw and paint as an amusement for them."

James had considerable artistic talent himself. "The paintings that I was most successful at were landscapes. I never cared so much about faces. I could never get them to look the way I wanted them to look. I was much better at landscapes than I was at faces. . . . There was so much beautiful scenery there. Snowtime, the snow seemed to be so perfectly smooth and white, and occasionally we'd see tracks in the snow. My brother and I could always tell the difference between a rabbit and a fox, different birds that would make those tracks. On our property was an old sawmill, down below a bridge. In the fall of the year it was surrounded by foliage of every kind, red, yellow, and green. And so many artists from various parts of the country used to come and paint. I recall one artist saying he'd been all over and had seen more picturesque scenes in the Berkshires than he had any place else. But I didn't appreciate it as much as I would have if I hadn't grown up with it."

James found drawing and painting rather boring after a while, but it was hard to find new things to do during the long, cold winters, when he and the other children were pretty much confined to the house. "We would draw and paint around the house there, doing the same things. One day, I saw a little advertisement—I think it was in *Youth's Companion*—that said I could get a camera and outfit for selling so many packages of sachet, and I knew that was a way I could get rid of all this drawing and painting." He was eight or nine years old at the time.

3

Early Experiments
in Photography

By the time James Van DerZee started thinking about getting a camera, the process called photography was progressing rapidly. But before the nineteenth century it had seen little advancement in three hundred years.

The forerunner of the camera, the *camera obscura*, was developed in ancient times. The Latin words mean "dark room," and the first kinds were small, darkened rooms whose only light source was a single, tiny hole in one wall. The light coming through that hole would cast on the opposite wall an upside-down image of the scene outside the wall with the hole in it. It was basically a large version of the pinhole cameras that children nowadays are taught to make out of a box with a pinhole in one side.

Artists began to use the camera obscura immediately because it helped them in rendering perspective, and many of the great art-

ists in history relied considerably on the device. An artist painting a Venice canal scene outside his window without the aid of the device would have trouble making the people on the opposite bank the right size to fit in the gondola gliding by. But if he covered the window leaving only a tiny light source, the image of the canal scene, with everything in proper perspective, would be projected upside down on the opposite wall, and he could trace it on drawing paper. By the eighteenth century, portable box versions were being made and equipped with mirrors, so the image in the box would be right-side up. Many artists and inventors must have wished that there was some way to capture the images made from light, so it would not be necessary to trace them on paper. What was needed was some kind of surface that was sensitive to light, a surface that would hold the image that was projected on it. But no one seems to have created that kind of surface until 1826, when a French amateur inventor, Joseph Niépce, managed to capture the image in the camera obscura on a piece of asphalt treated with oil of lavender. He called the resulting image a *heliograph*. Meanwhile, in Paris, Louis Daguerre had been experimenting with ways to record the camera obscura's image. Learning of Niépce's work, he contacted him and the two formed a partnership. Niépce died in 1833 and Daguerre continued his experiments alone. In 1837, he produced a photograph on a silver-plated sheet of copper that had been made light-sensitive by exposing the silvered side to the fumes of iodine, which produced silver iodide. After the plate was exposed to light in the camera, it was treated with fumes of mercury, which mixed with the silver in the areas of the plate that had been exposed to light. The image that was formed was then fixed on the plate by removing the unaffected silver iodide with sodium thiosulfate.

EARLY EXPERIMENTS IN PHOTOGRAPHY

Similar attempts to capture the image in the camera obscura were being made in England. In 1802, Thomas Wedgwood, son of the potter Josiah Wedgwood, was trying to record these images on paper and leather treated with silver nitrate. In 1835, a Cambridge scientist named William Henry Fox Talbot had succeeded in capturing images on paper that had been made light-sensitive by soaking it alternately in solutions of salt and silver nitrate and causing silver chloride to be produced in the fibers of the paper.

Both Daguerre and Talbot patented their processes and published their findings, so it was possible for any artist who wanted to do so to capture permanently the images in their boxes. A revolution occurred in painting techniques. Almost every artist recognized the process as a wonderful shortcut. It made unnecessary the long hours of drawing studies before a painting could even be started, and it captured details that the average artist frequently overlooked.

Of the two processes, Daguerre's become more popular, and the images came to be called *daguerreotypes.* As the general public became more accustomed to seeing daguerreotypes, they began to demand more realism in art, especially in portraiture. Observed a writer in *Living Age* in 1846: "[The daguerreotype] is slowly accomplishing a great revolution in the morals of portrait painting. The flattery of the countenance delineators is notorious . . . Everybody who pays must look handsome, intellectual, or interesting at least, on canvas. These abuses of the brush, the photographic art is happily designed to correct."

Until the development and widespread use of the daguerreotype, people who wished to carry around likenesses of their loved ones had hired painters to do miniature portraits, usually only a few inches in size. A daguerreotype was quicker and much less

costly to obtain, and by the mid-1850s portrait photography had almost completely supplanted miniature painting.

Photography was still unavailable to most people because the materials were costly and the process of developing was difficult. The layman had to go to a professional photographer for his pictures. Then, in 1851, an English sculptor named Frederick Scott Archer shared with the world his discovery of a new technique, called the collodion process. The negatives were glass and were treated with a solution of nitrocellulose in alcohol and ether before the exposure to light. The chief drawback was that the photographer had to process the plate while the solution was still moist, but it was nevertheless a much simpler process than had been available before, and it led to an increase in amateur photography. By 1880, that increase had become an explosion, as a result of the development of the dry plate. With the dry plate, the photographer did not have to sensitize his own plates, nor did he have to develop them immediately after exposure. He could buy plates already treated with a gelatin and could process them at his convenience after exposure. Once these further developments made photography available to the layman, a variety of hand cameras appeared at relatively low cost.

Americans adopted photography eagerly. New York had seventy-seven photography galleries in 1850, and by the 1880s the United States had become the center for further developments in the medium. George Eastman, a dry-plate maker in Rochester, New York, invented "American film," a paper coated with a bromide gelatin; later he introduced clear plastic film. He also invented and manufactured cameras, and in 1888 he introduced the Kodak, a name he coined. A box camera, 3¼-by-3¾-by-6½ inches, it came from the factory loaded with a roll of film

sufficient for taking one hundred 2½-inch pictures and cost twenty-five dollars. Once the owner of the camera had used up all the film, he sent the entire camera to the factory, where the film was removed, developed, and the prints individually mounted. The prints were then returned to the owner, along with the camera, which would come loaded with a new roll of film for an additional cost of ten dollars. "You Press the Button, We Do the Rest," was the Kodak slogan.

Eastman introduced less expensive cameras, including a five-dollar model. By 1896, the year James Van DerZee was ten, the Eastman Kodak Company had already manufactured one hundred thousand cameras. Amateur photography clubs proliferated, magazines devoted to photography flourished. By 1900, there were 27,029 professional photographers in the United States.

According to James, however, a camera was an uncommon item in Lenox. "There was a man who used to come around once in a while with a camera and take pictures. I remember one picture he took. We all went down in the backyard, and my father and mother, my sisters and brothers and I and the cow all lined up for the man to make his picture. And then he said it was too dark to make pictures that day and he would have to come back another time. So we made another appointment and he came back and made the picture, but I don't know whatever happened to it. We had a whole box of tintype and daguerreotype pictures at home, but I didn't know any of the people, and we didn't keep them."

James had previously expressed some interest in optical instruments, though not particularly in cameras. He was intrigued by the first moving pictures. "I saw them in the Town Hall. They just showed moving objects—people walking along the street, freight trains coming and going. That freight train coming looked

so real, I ducked down under the chair!" He was interested in telescopes. But he was not as interested in the camera itself as he was in the purpose it would serve—to give him something new to do—so he wrote to the magazine for the sachet.

Shortly thereafter, a package arrived containing twenty packets to be sold at ten cents apiece, and young James Van DerZee was in business. "It must have taken me about two months to sell all of it. There weren't many people around to sell it to, and when I'd sold some to everyone I could, I had to wait around until they used it up so I could try and sell it to them again. So I finally sold all the perfume and I sent the money in, and the next day I started running to the post office and the express office looking for this camera and outfit. And finally one day there was a red card in the box in the post office, meaning there was a package too big to go in the mailbox. My blood pressure must have gone up to the bursting point. I grabbed the package and raced back home and went up to my bedroom with it."

Inside the package, which was about half the size of a quart milk carton, was a small box that was supposed to function as a camera. It contained a piece of glass that looked like a broken eyeglass, which was the lens, and was equipped with a shutter that passed across the opening in the camera. Also in the package were envelopes containing chemicals, a developer, a clearing solution to remove stains left by the developer, a small box of 2½-by-2½-inch glass plates, and a set of instructions. James read them over carefully before attempting to make a picture, but he never did manage to produce a photograph with that outfit. "I was developing and developing, and one day I saw a scratch across the plate, and I thought that must be the picture. But after I brought it out into the light, I saw that the plate was all black. I

couldn't get any results because the camera was too cheap. It was really a box."

James's photography career might have ended right then, before it had even begun, but his curiosity was aroused. He wanted to produce an image on a piece of glass, so he determined to get a better camera. One of the summer people, Mrs. David Dana, had a big garden, and that summer James and Walter got jobs helping her set out her plants. "She'd give us twenty-five cents an hour, and I managed to save five dollars. That's how I came to buy my second camera. I bought it from a company on Chambers Street in New York, got it through mail order. It was a 4-by-5-inch Klieg camera, a box camera. I used to operate it on a stand. It took glass plates, so I did my own developing. There was no place around there that did developing, and you couldn't send away glass plates. I could still use that camera—if I could find a place that sold plates for it."

James was in the fifth grade by then and he practiced taking pictures of his class. The teacher saw them and asked him how much they cost. "Oh, ten cents apiece," James replied. "Well," said the teacher, "I'd like six of these, eight of those. . . ." James was ashamed to take the money. "So I'd make up a few and give them to her, and that was it. As a matter of fact, I didn't know people made a living at making pictures in those days. If I had known that at the time, I could have made a good living, because I was taking pictures of all the aristocrats; and there was only that one other man in Lenox who had a camera."

James's family was pleased about his new hobby. "Seeing the interest I had in that type of work, they were interested, too. After I got the more expensive camera, I began photographing the family, and they enjoyed seeing the pictures."

JAMES VAN DERZEE

James had his own room, and when he decided to turn his closet into a darkroom, no one objected. "There was a drugstore in town that sold photographic equipment, and you didn't need much for a darkroom in those days, just some chemicals and three trays and a darkroom light. We didn't have electricity then, so my light was a candle inside a collapsible metal enclosure with one side that was red glass. You'd have to put the prints out in the sunlight after treating them with the chemicals."

With every picture he developed, James, who taught himself almost everything he knows about photography, learned more about the medium and became sensitive to its relationship with other visual devices. "Magic lantern" shows became educational as well as entertaining. The magic lantern was a projection device incorporating an oil lamp (later, electricity) to project a cartoon image on a glass slide through a lens and onto a screen. Eventually it evolved into the modern slide projector. The various churches in Lenox occasionally had magic lantern shows. "That's one thing that kind of helped me with my pictures, because the slides they'd show in the magic lantern were practically the same as the negatives from the camera." But photography remained little more than an interesting hobby, a way to amuse himself and his family and "the aristocrats." He had no thought of making it a career, and as he said, didn't even know people could make a living at it.

"I don't know as I had any special aim in life when I was growing up. They say the secret of success is to be ready for the opportunity when it comes," says James. Still, no great opportunity caused him to quit school. He was simply bored with school and eager to get a job and earn some money. "I must have been twelve or fourteen. There were hardly any industries in

EARLY EXPERIMENTS IN PHOTOGRAPHY

Lenox, and very few public businesses—a hardware store, a couple of meat markets, two drugstores, a blacksmith shop." The quarries were still in operation, "but they were worked by the Italians. No blacks worked there. I wasn't interested in that work anyhow."

James's first job was in a boardinghouse. "They gave me ten dollars a month and my meals, and I figure I managed to save more than I do now." He went to Pittsfield to apply for a mail carrier's job, but he missed a qualifying mark on the test by one or two points.

The Aspinwall Hotel was built on the hill above the Congregational Church by General Thomas Hubbard in 1902, and John Van DerZee applied for a job there. He was getting on in years and was in poor health. He had contracted tuberculosis (as a result of so many winters of carrying and inhaling the ashes from the Trinity Church furnace, James feels) and the buildings and grounds were too much to take care of. "At that time, he was getting about fifty dollars a month. He should have been getting a hundred and fifty, since he had three different buildings to take care of—the church, the parish house, and the parsonage." The same year the hotel opened, John Van DerZee quit his job as sexton and went to work as a waiter at the Aspinwall.

James soon followed suit. His job as a waiter paid twenty-five dollars a month, and he was able to put a respectable portion of his salary into his bank account, which he sort of reactivated once he had quit school. The bank account had been opened for him some years before by Mrs. Richard Dana, one of the summer residents who had befriended him and Walter. She had started an account for each of them with one dollar at the Lenox Bank. At first, James had dutifully saved, but then he had spent the

money on things he wanted, like photographic equipment. Now, working for a living, he had money for things he wanted as well as money to save. He made friends among the other employees at the hotel. "One of the boys there was named James LaMare. He played violin and piano like I did." He did some photography work. He played piano and violin solos at various Lenox churches at Christmas and Easter, and on occasion the bellmen and waiters at the hotel asked him to play at their dances. It was a good life, if not a particularly exciting one.

His father did not fare as well, and a few months later he left the Aspinwall. James does not remember whether the work was too hard for the older man or whether he just did not like the job. "Money wasn't the problem. We had gardens and apple orchards, cows and horses, so we had a great deal of support from the land." Whatever the reason, John Van DerZee decided to go to New York to look for a job. Once settled, he assured his family, he would send for them.

It was a sad time for the extended family in the row of three houses on Taconic Street in Lenox. James would always speak of it as the time they "broke up."

James remained at the Aspinwall, quite content with his job. "I did all the food ordering for the guests I was serving, and there was always plenty of food. And I used to make pictures of the bellboys and waiters, and some of the guests at the hotel saw them and wanted me to make pictures of them. I was thinking that the next year I might decorate my room and have a regular studio there. But I had the misfortune to break a dish."

One day as he was placing a tray of dishes on the dishwasher counter, the tray tipped. A couple of dishes fell to the floor. It was a stone floor, and the crash echoed as if an entire tray had fallen.

EARLY EXPERIMENTS IN PHOTOGRAPHY

The hotel had a rule that the waiters were required to pay for any dishes they broke. Later, according to James, "The headwaiter said he'd heard I'd broken a whole trayful of dishes. I said I'd broken only one—a dish with a cover on it. There was a Greek dishwasher there and he said I'd broken a whole trayful. Well, he had a very inviting nose and he was standing a little *too* close to me. I popped him one . . . and I lost the job on that account. I was very sorry about it afterwards. I had just had my room all fixed up, intending to make a business that year . . . I never went in too much for fighting, but I was quick-tempered then. Later, I thought to myself, well, I could have paid whatever they wanted and forgot about it . . . and still had the job."

Finding himself out of a job, James realized he had few other opportunities for employment. "The reason most people come away from the country, it's hard to find employment, especially in such a small town. Once you were out of a job there, why, there was nothing to do."

He decided to join his father in New York. He had managed to save about two hundred dollars and he figured that would be enough to tide him over until he found a job in the city. Walter, who was also not much interested in school, decided to accompany James to New York, and in late 1904 or early 1905, when James was eighteen, the brothers set off. The trolley ride from Lenox to New York City cost them three dollars and fifty cents each.

4

Young Man in New York

"When I first came to New York, there wasn't any Harlem [as we know it]." An area called Harlem had existed since the days of the Dutch colonization, and indeed Harlem, originally spelled Haarlem, is a Dutch name. In the days when New York was New Amsterdam, the name Haarlem was applied to all of upper Manhattan. By 1900, the name generally referred to the area bounded by 110th Street on the south, 159th Street on the north, the East River, and the present-day Morningside and St. Nicholas avenues. Until the 1870s it had been little more than a poor, isolated village. After the 1870s it became increasingly an upper and upper middle-class residential area. Gilbert Osofsky, author of *Harlem: The Making of a Ghetto*, called it Manhattan's first suburb. The transformation from rural village to residential suburb had affected primarily the southern interior sections. Much of the waterfront and northern interior areas, isolated from trans-

portation, remained undeveloped, and in these sections could still be found the shanties of the poor, including a scattering of blacks. But the majority of black Manhattanites lived between Twentieth and Sixty-third streets, in the present-day midtown area.

Within these northern and southern boundaries, one of the most populous black sections was San Juan Hill—Sixtieth to Sixty-fourth streets, Tenth to Eleventh avenues—a highly congested area even at the turn of the century. It received its name after the Spanish-American War, because its frequent interracial fights recalled in the minds of some the battles of the war. Another black section was the Tenderloin, loosely defined by the scattered black enclaves between Twentieth and Fifty-third streets, Eighth to Ninth avenues. Its name was not unique. Many cities had their Tenderloin areas, marked by their high incidence of crime and corruption. Although no single large neighborhood was an all-black community, the concentration of blacks in Manhattan was increasing. In 1900, the number of blacks on the island was estimated between twenty-seven and twenty-nine thousand. By 1910 there were more than sixty thousand, over 50 percent of them from the South.

John Van DerZee found work as a waiter in the employee dining room at the Knickerbocker Trust, a bank on Fifth Avenue and Thirty-fourth Street. At some point, he would also serve as butler to Mrs. Richard Dana at 1045 Fifth Avenue. He lived near the Tenderloin in Miss Jennie Hall's boardinghouse at 160 West Twenty-fourth Street, near Seventh Avenue, and James and Walter moved in with him. They all shared one large room for which they paid four dollars and fifty cents per week.

James missed the beauty of the Lenox countryside, could not get used to the idea of *buying* things like apples, and found that

the salt air in New York made the winter cold much more pene-
trating. But once he had settled in, he began to enjoy New York.
He had never seen so many black people before; at first he found
it hard to believe that so many existed. And the bustle of activity
was a startlingly new experience for a boy who had grown up
under the shade of elm trees in a Massachusetts village. Trolleys,
hansom cabs, horses, and wagons rushed past him. Overhead, the
elevated trains roared by. He marveled at the number of shops
and stores, and wondered how they could all possibly stay in
business. He gazed in awe at the theater marquees and the
facades of clubs, and thought of the magic lantern shows and
other infrequent public entertainments that had been available in
Lenox. "It was very exciting. There were so many opportunities.
And what I liked most about New York was that no matter what
you were interested in, you could always find somebody better.
And there was no limit to how far you could go in any line you
might be interested in."

James was not sure what line he was interested in, so he started
looking for a job waiting tables or operating an elevator. He
looked for such jobs because he knew they were the ones he was
most likely to get. "You knew what kinds of jobs you could expect
in those days, because in the papers they'd print 'Colored,' or
'White.' Sometimes they'd say 'Light Colored.' If it didn't say
Colored, why, there was no need in going, because you wouldn't
get the job.

"When you grow up with such things, you just accept them. At
that time, you wouldn't think of going down to Macy's looking for
a salesman's job, or to some of these banks and look for a cashier's
or teller's job. If you went in there looking for one of those, they'd
give you a long paper to fill out, and if you filled it out they'd

think you were crazy. Call a paddy wagon! I wasn't going to be any trailblazer."

John Van DerZee managed to get both his sons jobs as waiters at the Knickerbocker Trust building, but neither stayed there very long. Both saw their comparatively menial jobs as temporary. "We started attending night school, my brother and I. We took up bookkeeping, but I never was very successful at that because my accounting always came up short." Walter never went on to be an accountant either.

James's life was rather unfocused during those early days in New York. He worked at various elevator jobs, did some photography for friends and acquaintances, played his violin, and took advantage of the plethora of musical entertainment that was available. "I went to concerts and shows—orchestra shows. At that time I didn't know the difference between an orchestra and a band. I heard that Sousa's band was going to be in a place one time, and I got tickets and come to find out there were no fiddles in it. I was a little disappointed."

He went to nightclubs at times. "In those days you could *afford* to go to the nightclubs—two or three dollars would last you the whole evening. It was a very good source of amusement." And after a while it occurred to him that he might be interested in a career in music. "There were not many musicians at that time. There was an Amsterdam Musical Association and the Clef Club. Jazz music was just coming out, and there was quite a demand for musicians to go out to the clubs and to play private entertainment. It seemed to me there were quite a few opportunities for a musician."

James joined the Amsterdam Musical Association and the Clef Club and made some contacts through those organizations. "I

took some courses at the Cogden Conservatory of Music at 123rd Street and Seventh Avenue. Then I met a piano player from Jamaica and he had a little band. We'd go down to Grand Central Station. There was a dancing school down there, and we played there a few times. We played at other dancing schools. Then he got a chance to go to Europe with another band, so that broke up our band. He was over there quite a while, until the war started. After that, I did mostly church work for a while."

The church was the most important institution in the black community. Historically, it had been the center not only of black religious life but of black social and political life as well. Next after the church in importance were the mutual aid societies, like the African Society of Mutual Relief, which were formed primarily to ensure proper burials for their members but which eventually provided care for orphaned children and destitute adults in the community. There were black fraternal organizations like the Odd Fellows, Masons, Elks, and church-affiliated women's groups. All of these institutions and organizations sponsored fund-raisers and other social functions, and in the early 1900s in New York they were a major forum for respectable black musicians.

James did not make much money playing at church and social functions. He still had to work full time as an elevator operator. Making a career of music remained something he hoped to do, just as he hoped to study languages.

"At that time I was particularly interested in French, and I had copied quite a little at home. In New York, I was working as an elevator operator at some of those apartment buildings, like 344 Riverside Drive, where they had French maids and governesses teaching the kids French. I had been quite interested in French

when I was growing up. During the long winter hours I had a book and I studied. So I wanted to take up a couple of languages at the Cortina School of Languages [12 East Forty-sixth Street]. But after I became involved in matrimony, why, that changed my mind."

A couple of years after his arrival in New York, James met Kate L. Brown. "I was playing a violin solo at St. Mark's Church. After the concert, she was one of the ones that congratulated me, and I think I made an appointment to see her sometime. I did call on her, on several occasions. Her name was Katie Brown. She was from Virginia, and 'that is the place that'll win ya.' "

Kate Brown certainly had some winsome qualities. She was young and handsome and possessed a quiet Southern charm. She was also fun-loving, fond of travel, and had a stubborn, no-nonsense attitude that James found attractive. He saw it as strength. Most of all, he was struck by her beauty. A tall, statuesque woman, she carried about her an aura of dignity that is clearly evident in the Lenox pictures of 1909.

James had not planned to get married until he had about five hundred dollars in the bank. He figured that was a proper nest egg. When he did get married, he had three bank accounts, each containing between sixty and seventy dollars. "When she said, 'I believe you've ruined me,' I could see all my dreams bursting like soap bubbles in the air." The classic conversation followed:

"I said, 'You say it's me, so let's get married.'

"She said, 'No, we won't get married. I'll go off and you'll never hear from me again.'

"I said, 'Why do that? You say I'm the father. Might as well get married.' "

Under the circumstances, James thought marrying Kate was

the manly thing to do. "So I wound up carrying her to a minister, and they say there's more knots tied with the lips than any other way." He was twenty years old.

James A.J. Van DerZee and Kate L. Brown were married by the Reverend Sims at Union Baptist Church in March, 1907, and thereafter moved into a railroad flat on West Twenty-ninth Street. The rent was twenty-nine dollars a month. In those days, apartments were still quite reasonable and easy to get. "You could go down any street and see signs up in practically all the buildings. And if you liked the neighborhood and the apartment, you could make arrangements. Sometimes the landlord would give you a month's rent free and pay your moving expenses." At the time, however, the newlyweds did not have much to move.

"I had to buy two locks. I put the locks on, and there was nothing in the place. Began to get late. Needed a table, had to go out and buy a table. Began to get hungry, didn't have any silver, go out and buy a knife and fork. No bread . . . had to buy bread. Didn't have a spring, didn't have a mattress. I said, 'Oy-oy-oy, this is something.' Had about forty dollars in all three bank accounts." To economize, the newlyweds soon moved to a fourteen-dollar-a-month apartment on West Sixty-third Street, near Amsterdam Avenue.

James and Kate survived, he with his elevator and waiter jobs, she working as a seamstress, as she had before they were married; but as her pregnancy progressed, James decided she should have the baby in Lenox, a decision that delighted James's family. Susan Elizabeth Van DerZee, Jennie, Charles, and Mary missed the men in New York and longed to have the family all together again. Although John Van DerZee and his sons visited frequently, the separation was difficult for all of them. "We went to Lenox in

the springtime. Rachel was born in September of that year, September 22." A chubby, bright little girl, she would be the subject of many of James Van DerZee's photographs of that early period. When Rachel was born, Susan was delighted with her first grandchild and would have liked them all to stay longer. But Kate wanted to visit her people in Virginia. So, later in the fall of 1907, James and Kate went to Phoebus, Virginia, with their infant daughter.

"We went by boat, the Old Dominion line. It was a nice trip. My wife knew just how to get there. I have pictures that someone took of us on the boat, going and coming. And coming back, just before the boat landed, I lost a brand-new straw hat. It blew off and I looked at it going down and down. It floated on the river for a while . . . In those days, everybody got straw hats in the springtime and they wore them only up to the first part of September. People would laugh if you wore it any longer than that. You'd feed the straw to the cows."

In Virginia, they stayed with relatives of Kate's, named Jenkins, and James got a job as a waiter at the Chamberlain Hotel in nearby Old Point Comfort. But he accomplished much more during their six-to-eight month visit. He found a rare appreciation for both his music and his photography at the Whittier School, a preparatory school for all-black Hampton Institute in Hampton, Virginia, which had been established in 1868 to educate former slaves and had become a highly respected trade school by 1900. James enrolled in music classes at the Whittier School.

"I was a big professor [a common title of respect for musicians] down there, and yet I was myself trying to get an education. Of course, I was never too hot at the piano or the violin, but at the same time, I was so much better than the rest. There was

one professor at the school who was very good, and I couldn't understand why they thought I was so much better than he until I figured it out one day. I figured it must be that the stuff he was playing was so difficult that their untrained ears couldn't follow him. I played pieces like 'Ave Maria' and Mendelssohn's 'Spring Song,' simple pieces that had an even, flowing melody that was easy to follow. But he'd be playing something that would be too much for them. They could appreciate my work, so they liked my work much better."

He became a minor celebrity among the black residents and was called on to perform at many benefits and recitals at area churches. He spent a week in Cape Charles, where he was invited to play at a benefit to raise money to buy a piano for the Whittier School. "I thought they had quite a program, but come to find out, I was the only one on the program. So I had to do a little playing on the violin. I played a little on the piano, and I told them it was a piece that they played at the New York Hippodrome and many of the leading theaters there."

He also found that his photography was appreciated and encouraged. In New York, he'd kept up with his photography, "in private, on the side. Wasn't getting very much for it because I wasn't charging very much." In Phoebus, particularly at Whittier, he was treated like an expert, and he responded accordingly. His photographs of neighbors and friends in Phoebus and of teachers and classes at the Whittier School show his natural sensitivity to composition, texture, and light. One of the best-known photographs of this period is the interior of a blacksmith's shop in Phoebus. Critics have likened its lighting and texture to the work of the Italian Renaissance painter Caravaggio, who became famous for his dramatic contrasts of light and shadow, but twenty-

YOUNG MAN IN NEW YORK

one-year-old James Van DerZee knew nothing of the artist. As he remembers, his inspiration was much simpler.

"A couple of colored fellows had a blacksmith shop down there. Reminded me of a poem I learned in school, 'The Village Blacksmith': 'Under the spreading chestnut tree the village smithy stands . . .' " The blacksmith shop in Phoebus was not under a spreading chestnut tree, but James Van DerZee imbued his photograph with a sense of lyricism and poetry all the same. "Music and art, they all seemed to work in conjunction, to my way of thinking."

For that photograph, and others that he took in Virginia, James used materials similar to those he used in Lenox: heavy glass plates—Eastman, Stanley, and Hammer dry plates with a speed of about forty—and flash powder. "We were obliged to use flash powder in those days. It produced very good illumination, but there were technical difficulties. If you put too much powder in, why, you were liable to blow your head off, or at least your hand. I knew people who got burned pretty bad. I burned my hand sometimes, trying to light the powder. Then I noticed an advertisement; it showed a tray and a partition with a hole in it, so you lighted the powder with a match that you put through the hole. I started using that. There were others where you lit the powder with a gun . . . had a cap in there that ignited the powder.

"You'd open the lens of the camera, let the powder go off— bang!—and close the camera up. 'Course there was a great deal of smoke to it afterwards. If there was a high ceiling it was all right, because it took a little time for the powder to go up and come down. I'd try to make a second shot quick, because when all that smoke came down everyone would start coughing and choking. With a low ceiling, the powder would go up and spread around

The blacksmith's shop, Phoebus, Virginia.

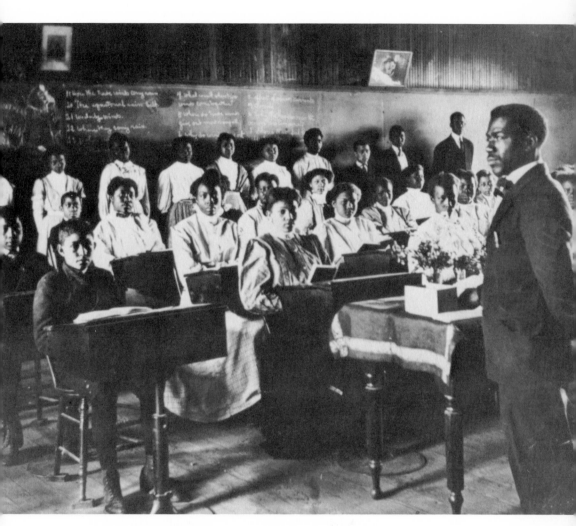

Teacher and class, Whittier School, Phoebus, Virginia.

and come down, and there was no time for a second shot. We had to get out of there before they started coughing!

"Some big concerns had flash bags they put the powder in, and had it connected up with electricity. Flash went off, and it wasn't so bad. Then later on, they came up with the flash bulbs and that was a great improvement. There wasn't any smoke. But with the flash powder you could make the illumination as bright as you wanted."

He made his own developers. Although they were available commercially, they were expensive, so he bought the chemicals and mixed the solutions himself. "We had the hydroquinone, sulphite of soda, potassium, and edinol sometimes. Sometimes we used what they call pyro." Hydroquinone is a developing agent. Sulphite of soda (or hyposulfite) is a widely used name for sodium thiosulphate, a fixing agent. Various potassium compounds are used as hardeners, restrainers, bleachers, sensitizers, toners, and intensifiers. Edinol was a developing agent, now obsolete for that purpose. Pyro (pyrogallic acid) was the standard developing agent in plate developing and is still favored by some photo developers. Later, commercial developers would become less expensive and flash powder would be replaced by artificial lights, but all that was in the future for James Van DerZee.

Kate's wishes and his own ego having been satisfied, James was anxious to get back to New York. "I met some very nice friends down there and I did a lot of photographic work down there, but they used to segregate colored people . . . like on the train: white folks up front, colored folks in the back." That situation was distasteful to him and he felt he could never get used to it. Besides, though he enjoyed the respect he had received from the people at

the Whittier School, he was still determined to try to make it in music in New York.

By the time James and Kate returned to New York in the spring of 1908, Harlem was, in James's words, "breaking loose." The process had already begun back in 1878–1881, before he ever arrived in New York, when Manhattan's three elevated railroad lines had been extended to 129th Street and plans had been made to push them even farther north. Harlem's major drawback as a residential area had always been its isolation from the core of the city. The northward extension of the elevated lines had made living in Harlem a more appealing prospect. Land speculators had moved in, purchasing land and erecting town houses and apartment buildings in anticipation of huge profits. In their frenzy of development, they inflated land prices, built too many buildings, and overextended themselves by investing too heavily in the promise, rather than the reality, of expanded transportation facilities. By 1904–1905, they realized what they had done. Rows of empty buildings faced the wide, tree-lined avenues—buildings that were producing no revenues but whose mortgage payments were still due at the bank every month. The elevated lines were nowhere near completion. Desperate to recoup their losses, speculators and realtors turned to the burgeoning Negro population downtown and found willing tenants in the occupants of the overcrowded, slum-ridden Tenderloin and San Juan Hill areas. To these blacks, Harlem was like the Promised Land, a "decent" neighborhood. Many of its new apartment houses had never been occupied, and if the rents were steep, well, blacks were used to being charged higher rents than whites anyway. They began to trickle into Harlem.

JAMES VAN DERZEE

James and Kate returned at a time when that trickle had become a flow, and they joined it, moving into the Victoria Apartments at 138th Street and Lenox Avenue. Kate was pregnant with their second child. Emil Van DerZee was born in New York a few months later.

James went back to operating elevators and waiting tables. Some jobs were satisfactory, others not. "I did more elevator work than anything else, different office buildings and so forth. Had quite a lot of experience, too, because they had so many different kinds of businesses. I never went into those jobs that I didn't try to see what the other fellow was doing." He tried to get his business education "in the field," for it was the only place he could get it, given his circumstances.

The low-paying elevator jobs never bothered James very much, even though he had a family to support. "Things were cheaper in those days. Hamburgers, frankfurters at five to ten cents a pound, four to five pounds of potatoes were a few cents. Milk was five cents a quart, and if you brought your own container you could get it for three cents a quart. Bread was five cents a loaf. I don't remember ever going hungry."

Kate took in sewing when she could. James got paying music jobs whenever possible and gave private music lessons. "People would see you playing different jobs and they'd want to know if you taught. You could get a lot of students that way. Didn't make much money at it in those days—fifty to seventy-five cents per lesson—but it all added to the monthly income." He took on other sideline enterprises when necessary. "I always did like selling, although I never applied for any selling jobs. I used to go down to the factories and buy shirtwaists—women were wearing a lot of

YOUNG MAN IN NEW YORK

shirtwaists and shirts in those days—I'd buy them at wholesale prices. Then I'd sell them. Buy them downtown for a dollar to a dollar-fifty, sell them for two or three dollars. I never had just one job."

James was still primarily interested in music, but his positive reception as a photographer in Virginia had caused him to entertain the notion of opening a studio in New York. Kate, however, was not supportive. She did not mind his operating out of the apartment on a part-time basis, but she was against a full-time business. "Every time I mentioned going into business, she'd say, 'No, you'd better get a job. You'll at least know where your money's coming from.'"

"She had more experience in those things," James would later admit. "She'd been on her own when I met her. I hadn't been too long out of my own house, and I was still with my father. People had taken care of me. And I felt if I paid the landlord once or twice he oughta lay off me for awhile, but I found that every month he was right there again, wanting money. I didn't have the sense of responsibility that went along with having my own apartment and being married. But I learned, and I've since paid out many and many a dollar! The years teach much that the days don't even know."

At times, however, James wondered just what he was earning money for. His and Kate's relationship was not a particularly happy one. Both had hoped the arrival of Emil would help, but the little boy's life was tragically short.

Although the Victoria Apartments had been intended as a luxury building, once blacks began to occupy it, the landlord grew lax. "The apartment was very cold that winter," James recalls.

Little Emil, barely a year old, caught pneumonia and died. His death caused a noticeable crack in a marriage whose foundation had not been very solid to begin with.

"We seemed to have different ideas, didn't see eye-to-eye. She was more of a Southern gal. She didn't have the integrity of the second one." Kate wanted to go away every summer, to Buckroe Beach in the town of Hampton, Virginia, or to Portland, Maine, where "she did a little sewing or something." She would take Rachel with her. James understood his wife's desire to get away from the heat and humidity of the city and agreed that Rachel should have a chance to run free in the country. "Trouble is, Kate would want to close up the place—want me to get a room while she was gone—and I didn't see much in that."

He missed Rachel when her mother would take her away. "I was teaching her to sing. I'd play little pieces on the piano for her to sing. I remember one piece she used to sing at that time, called Blind Pig. The teacher tells the kids to spell Blind Pig and they spell it B-L-N-D P-G. The teacher asks where are the I's, and the kids say the blind pig *has* no 'eyes.'"

He also photographed his little daughter frequently, and his pictures of Rachel as a toddler are among the most memorable in his work.

Periodically, they visited the family back in Lenox, and in 1909, James photographed Kate, Rachel, and other relatives. These photographs are some of the most remarkable that he ever produced, although he was still an amateur. It is evident that he took great care in composing the photographs—selecting the backgrounds, positioning the subjects, taking advantage of the natural play of light and shade in the outdoor settings. It is also evident that he was very proud of his family, for each person is

depicted in a flattering manner. James could have taken the photographs at any time, but he chose to wait until each subject was ready and none would be caught unawares. Considering the limitations under which he was working—the heavy glass plates, the long exposure time, the uncontrollable aspects of the outdoor setting—both he and his family must have been remarkably patient. The finished products are beautifully successful solutions to the problems of composition, depth, and detail in outdoor light. The ideas are simple, but the close attention to every element in the composition places them far above ordinary photographs. Because he used large-size negatives, the background detail became almost as important as the human subjects, and could stand production in very large prints.

One photograph shows Kate and Rachel out for a walk in the woods; they've crossed a stream on a narrow footbridge and picked bouquets of leaves and flowers. The bridge, almost parallel to the bottom edge of the photograph, is positioned at a slight angle, leading the eye to the subjects. Behind Kate, the thick trunk of a tree reinforces her own ramrod straightness. The huge bunch of leaves in Kate's left hand softens the composition and at the same time directs the eye back to the bridge. Even the rocks in the stream below seem to lead to the dignified strollers.

Another photograph shows Kate wheeling Rachel in her carriage along a lonely stretch of road. It is a barren time of year in Lenox. Kate wears a heavy coat and gloves. Though the photograph is black and white, the weeds along the roadside seem brown and dying. Kate's long shadow suggests the approaching winter, and in the carriage little Rachel yawns as if settling down to a long winter's nap.

The series of Lenox photographs taken around 1909 includes

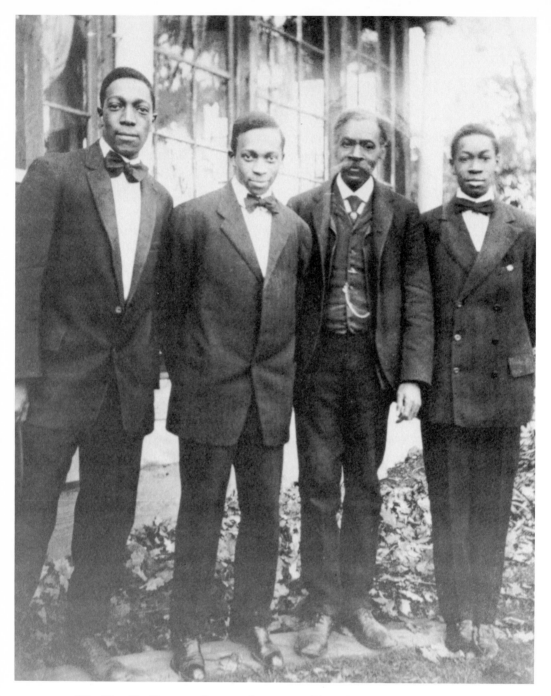

The Van DerZee men, Lenox, about 1909. *From left*: James, Walter, John, and Charles.

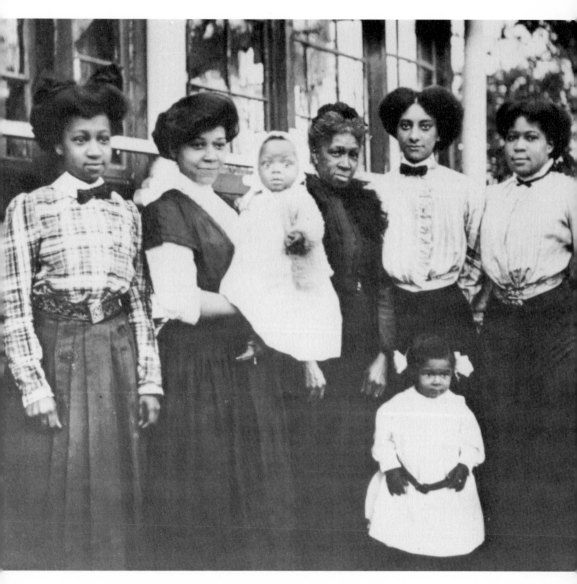

The Van DerZee women and children, Lenox, around 1909. *From left*:
Mary, Walter's wife, Catherine (called Kate) with son Reginald, Susan
Elizabeth, Kate, Rachel, and Jennie.

James and Kate, Lenox, about 1909.

Kate and Rachel Van DerZee, Lenox, about 1909.

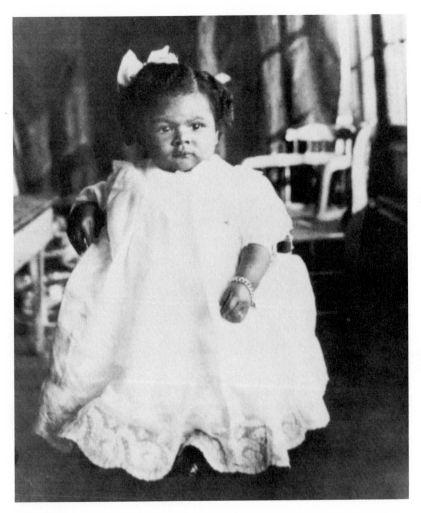

Above and opposite: Rachel in Lenox, about 1909.

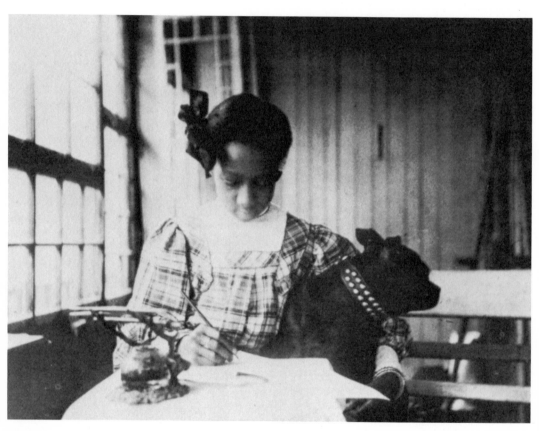

James's sister, Mary, in Lenox.

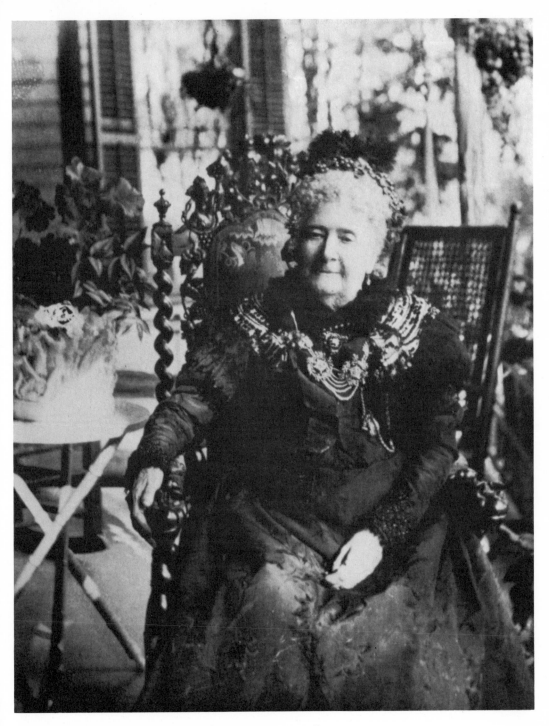

Mrs. Turner, one of the Lenox "aristocrats."

photographs of James's sister, Jennie, who was at home that summer. She had remained behind in Lenox when her father and brothers had gone off to New York City and had attended the Kellogg Art School in Pittsfield. In 1907 or 1908, she had married Ernest Toussaint Welcome, and by 1910 they would settle in New York and appear in the very first issue of the New York *Amsterdam News*, which is today the largest black weekly newspaper. Ernest operated a business at 90 Nassau Street, but what sort is uncertain. Although Welcome is listed in the 1910 City Directory (similar to the present-day telephone book and Yellow Pages combined) as "vice-president," there is no indication of the kind of business it was. Ernest would operate a variety of businesses in his lifetime, including a magazine, *Colored American Review*, a shoe store, a sight-seeing bus service, a domestic help agency, a realty company, and, with Jennie, a conservatory of art and music. "He was a very good promoter. Anything he set his mind to, he was successful at it." Personally, James felt his brother-in-law should have considered a singing career. "He had the finest bass voice I ever did hear. He should have sung professionally."

The Welcomes had chosen to live in Harlem, for the movement of blacks into Harlem was steadily increasing. The black migration to Harlem intensified after Negro boxer Jack Johnson defeated the "Great White Hope," Jim Jeffries, in 1910. Says Van DerZee, "I heard that at one time Jack Johnson was an 'African Dodger' at Coney Island. Stick your head through the canvas there. Folks would throw balls—hit the nigger on the head, you get a ten-cent cigar. And he's ducking those balls. Sometimes those guys that came in there were pretty good ballplayers. I guess that taught him how to be such a good fighter." Incensed at

the Johnson victory over Jeffries, outraged whites rioted, smashing buildings in the Negro sections. Rather than rebuild, many shopkeepers followed the northward move of their clientele.

Ernest and Jennie Welcome moved into a three-story brownstone at 221 West 134th Street, and at last it was possible for the family to be reunited. Susan Van DerZee sold the house in Lenox and traveled with Charles and Mary to join her daughter and son-in-law. John Van DerZee moved in, and so did Walter and James and their families. It was a happy time for the Van Der Zees, who had not lived together under one roof for eight years. What Ernest Welcome thought about having all these Van DerZees descend on him is not known.

"That was before Harlem was as densely populated as it is now," and before blacks were in the majority. At that time, a saloon in the heart of Harlem could be a dangerous place for a black. One night, when James was with a friend, "He insisted on my having a drink with him, although he'd already had several of them. So we went into a saloon on 138th Street. We opened those little half doors and I saw them all standing around there, a lot of Irish truck drivers, longshoremen, and the place didn't look very inviting to me.

"He goes up to the bar and demands some whiskey. The bartender handed him a half-empty bottle. 'I don't want no half-empty bottle,' my friend says. 'That all you got here?' The bartender kind of looked at him, and I saw the other guys looking at each other out of one eye. The bartender slowly and nonchalantly comes out from behind the bar and opens up a case on the wall, gets a fresh bottle and puts it on the counter for him. We had a couple of drinks. The next thing I knew there was some scuffling

going on and his hat went out the door. I hollered, 'Come on, fellas, don't bother him. He's had a couple of drinks.' We got out of there! I wasn't going to get into any affairs of that kind.''

At 221 West 134th Street, Jennie started an enterprise about which she had dreamed for years, the Toussaint Conservatory of Art and Music. James set up a small studio in the Welcome home, although it was not part of the Conservatory. For him, photography was still a mere sideline.

The Toussaint Conservatory was located on the ground floor of the brownstone. Behind the conservatory and upstairs were the family's living quarters. James's small studio was on the second floor. It was here, in 1910, that James saw "something that wasn't there" for the second time.

John Van DerZee was in the final stages of tuberculosis. "My father was in a room on the top floor in the back. He was sick, and he hadn't been out of that room for I don't know how long. One morning, when I was in my studio, I noticed he passed by the door. Before I could say anything, he went upstairs. He didn't say anything, just passed by, carrying the cup he used to expectorate in. So when I went downstairs that day, I said to my mother, 'Pop have much of an appetite this morning?' She answered, 'I haven't taken his breakfast up to him as yet.' I said, 'Didn't he eat when he was down here?' My sister kicked me under the table and said, 'Jim, you know Father hasn't been out of that room in months.' We got into a red-hot argument about that, but I never asked him about it. He was very sick."

Sadly, within a year after they had at last been reunited, the Van DerZee family lost John Van DerZee. "He died at this school of music and art . . . in the private building there . . . my sister's school." Within a few months after his death the family "broke

up" again. Walter and his family moved out to Jamaica, Queens, where he worked for the Loft Candy Company in Long Island City as a stock clerk. Mary died at a tragically young age. "She was only about fifteen or sixteen. Seems that she was standing on a chair reaching for something up in a closet and she fell and hurt her stomach. She died in St. Luke's Hospital."

Then Charles died. He was only eighteen or twenty. "I don't know how long he was sick or anything. I don't even know where he was living. I have very little recollection of him . . . very little recollection of him."

By 1911, the Welcomes had moved to a five-story, fifty-foot-wide building at 186 West 135th Street. While Jennie operated her Conservatory there, Ernest rented space at 114 West 135th Street and ran a domestic help agency. (The 1911 City Directory listing reads, "Welcome, Ernest T., servants.") James, Kate, and Rachel moved, too, first to 59 West 139th Street, then to 145 West 143rd Street. Kate's insistence on his not keeping their apartments while she and Rachel were away summers may have accounted for some of their numerous moves. By 1913 they were living at 552 Lenox Avenue, and in this year and at this address, James listed himself in the City Directory for the first time: "Van DerZee, Jas., musician."

The migration of southern blacks to New York had resulted in the opening of more restaurants and clubs and vaudeville theaters, not to mention the establishment of more social and fraternal organizations, not just in Harlem but in Brooklyn and parts of Long Island where Negro communities arose. Music was an important part of any social function, and in this era before radios and jukeboxes there was much more live music than there is today. Musicians would play for a small fee or for tips alone,

since most entertainment places were small and simple and catered to a hard-working but not particularly affluent clientele. James was beginning to get more jobs in music, and he figured it would not hurt to advertise.

Although he played and on occasion taught both piano and violin, "I was more successful with the violin than the piano. Played all kinds of music on the violin—waltzes, ragtime—played Scott Joplin's tunes, the popular songs of that time. At the time I was doing music work, it was mostly ragtime. I had quite a repertoire of music." Scott Joplin was living in New York then, but James never met him.

"The piano we had was a Horace Waters parlor grand, three-legged. Although it was a small piano, the spinets take up less room than the parlor grand. Had two types of violins. See, there is an orchestra violin and there is also a solo instrument. One was louder and stronger than the other. The solo has more of a sweet tone. The orchestra violin was a Joseph Skinerian. The other was an imitation Stradivarius. There used to be a great many of them made years ago, which are now almost as old as the regular Stradivarius violins.

"After violins went out of style they had what they call bandolins. They were like a banjo but they were shorter necked and strung the same as a violin. Instead of bowing them you picked them with your hands. And it seemed like at some of the affairs they preferred to see the musicians with banjos than they did with violins. So they all converted over to the bandolins."

James Van DerZee had new cards printed up after that change in taste. Whereas his earlier cards had advertised him as a violinist, the new ones advertised him as both a violinist and a bandolinist.

YOUNG MAN IN NEW YORK

He played for churches and private parties. He kept among his papers a handwritten note from an Emma Dorsey, 138 West 53rd Street, requesting that he play for her on the 5th of February, 1914, "in the evening." He also had a musical group. "I had a little five-piece orchestra called the Harlem Orchestra, and we played dancing schools, roadhouses [restaurants, in suburban areas]. We went out to various neighboring towns. I played violin and bandolin, mostly. I had a regular piano player."

Among his papers is a card advertising the College Inn Dancing Pavilion in North Beach, Long Island, a dance hall "for colored people only" with "Music by the Harlem Orchestra." "We would travel by train ususally, but I remember one job we had out on an island and we had to take a boat. I had a little clarinet player with me named Lee and he was afraid of the water. We persuaded him to go with us, and when he saw a great big boat, he didn't feel so bad. But then we passed this big boat and walked down to this little rowboat that we were supposed to take over to the island. We got him into it and over there somehow, but afterwards he tried to figure out how he could stay over there to keep from having to come back. A place called Berrien's Island . . . had a very strange smell out there.

"We were always in good surroundings—that's what I liked about music. You go out to one of these roadhouses to play and the waiter meets you at the door with a trayful of drinks, says, 'You fellas come in and sit by the fire and warm yourselves. When you get warm, why, you can give us some music.'" It was a joyful, gleeful life.

"The colored musicians were just getting to be popular because they had a certain jazz technique that seemed to be pretty good to dance by. The Castles [Vernon and Irene, a famous husband-

and-wife dancing team] and all those white dancers at that time always hired colored musicians."

Still, he was not earning a living at music, and he continued to work as an elevator operator in various buildings in order to support his family. He worked at Wanamaker's department store on Fourth Street for a while. "They had an orchestra there for the employees, and those of use who were in it used to have an advantage over a whole lot of other employees because we'd be given time to practice and hours for entertaining. I was first violinist in the Wanamaker orchestra."

None of these jobs lasted very long, however. He would work for a while, then get bored or find a better job and move on. In 1914, finding himself out of a job, his musical career progressing slowly, the high Harlem rents difficult to meet, James went job hunting in Newark, New Jersey. He applied for a job as an elevator operator for an insurance company and was hired. He and his family moved to Newark. "Had a room there with a Dr. Scott, my wife and I and our child, Rachel. Only paid two and a half dollars a week for the room. One of the jobs I had there was paying five dollars, so I had two and a half dollars to live on, outside of what I earned in my music work. Of course, music jobs weren't paying very much. They paid two or two and a half dollars at dancing school; balls that would last until two or three o'clock in the morning were paying five to six dollars." Later, James also worked as a waiter at Newark's Continental Hotel.

One day he noticed an advertisement in the paper. "Some photographer wanted a darkroom man, and I figured I was 'dark' enough for the job! The man had a concession in a Goerke's department store. It was a cheap type of work—three pictures for fifty cents, finish while you wait.

"So, I went and answered this ad, and he said he didn't know. He wanted a man who could photograph, too, and he didn't know if his customers would stand for my photographing or not. So—I figured he knew more about his business than I did—I left. A month or so later, I saw another ad. Not knowing it was the same place, I went back again. This time he decided to try me out."

For a while, James did only darkroom work and watched his employer take his quickie shots of his customers, among them shop girls who would come in every week. "He'd just sit them down, snap the picture, and say 'Next!' Mothers would come in there with their babies. They'd want to fix the baby's dress or hair ribbon. But right away, he'd say, 'Stand back, I'll make the baby's picture.' Bam! The picture would be made."

To James, who always took considerable time and great care to compose and take pictures, his employer's lack of concern was disgraceful. "He had formerly been an operator in a high-class studio—called White's, I think—but you wouldn't know it from the way he worked at Goerke's. He didn't have anything to teach me."

The Jewish holidays arrived and James's boss went home, leaving James in charge of the concession. The older man was not a little fearful that by the time he returned, his customers would have stopped coming. But he need not have worried. To be sure, some of the customers were surprised to see a black photographer, but James quickly allayed their misgivings. "I'd take time with them—you know, sit down and talk to them ahead of time, get their natural expressions and so forth. It was interesting work for me. I got a chance to do some experimenting with lights and different poses. I'd take time to get good pictures of them."

Back from the holidays, James's boss faced a situation he had not anticipated. He'd lost a lot of customers, all right, but not

because James was black. He'd lost them because they preferred his Negro assistant. "They'd come by there looking for me. They'd say, 'Is the colored fellow there?' He'd say, 'You want a picture made? Come in, I'll make your picture!' They'd say, 'I'll wait. I'll come back.' So then he'd have to say, 'Come out here, Jimmy. Somebody wants you to make their picture.'"

It seemed to James that if he could be successful taking pictures for his boss, he could do the same thing for himself. But he hadn't the money to establish a business. Back in New York, Ernest and Jennie were still operating the Toussaint Conservatory of Art and Music (Ernest had apparently given up his domestic help business), and they suggested that James open a professional studio as an adjunct to the Conservatory. The idea appealed to James. "I borrowed enough money to get out of Newark and went over there and opened up a studio." James and Kate took an apartment at 63 West 140th Street, and James went to work for his sister and brother-in-law. There, he did portrait work, including a photograph of Blanche Powell, older sister of Adam Clayton Powell, Jr., who would grow up to be a powerful minister in Harlem and the first black Congressman from New York. "He and his sister Blanche used to take piano lessons from my sister. That was back in 1914, 1915." Blanche would have been about seventeen at the time. James also taught piano and violin at the Conservatory.

At about that time, James had one of his photographs published in *The New York Times*. "The man's name was Parsons. He was the highest paid counselor at that time. He established the New York Sugar Trust. I have a letter from John E. Parsons—his daughter was a Sunday school teacher of mine—thanking me for the picture of his grandfather that was used in *The New York*

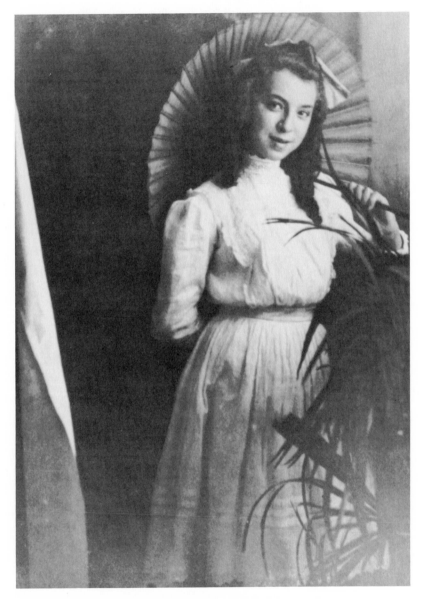

Blanche Powell, about 17 years old. Van DerZee superimposed this photograph on that of her funeral.

Van DerZee's cousin, Susan Porter, about 1914.

A Canadian performer.

Jeanette Reedy, a nurse, posed in a swimming costume.

Times." But publication of the picture did little to further the photography career of James Van DerZee.

Photography remained a part-time business. James still had not given up his hope of a music career. He listed himself in the City Directory in 1915 as a musician at 63 West 140th Street and in 1916 at 48 West 139th Street. But he still was not making enough money to support his family. He got a job operating an elevator at the Chatsworth Apartments, 346 West 72nd Street. His salary was thirty dollars a month, but there were fringe benefits. "I was friendly with all the maids and I got a good many free meals—coffee every morning, lunches. Christmastime, everybody gave you two dollars, five dollars.

"I met a great many different people there. One woman was a singer, and I remember taking Enrico Caruso up to her apartment one time. The Loews, the theater people, lived there, and there were one or two kept women. I remember one who was very fine. The man who was taking care of her used to come in every week, sometimes a couple of times during the week. He was in the pen business, selling pen points for fountain pens. Yes, I met a lot of people there."

He had no way of knowing, when he applied for the job, that he would also meet the love of his life there, that the experience would in many ways change the course of his personal life, and indirectly, change the course of his professional life as well.

5

The Picture-Takin' Man

"It was a big apartment house. I guess a lot of people in the house didn't have phones, and there was a switchboard on the ground floor, connected with the rooms upstairs. The telephone operator was the most beautiful young lady . . . her name was Gaynella."

Gaynella Katz Greenlee (who always signed her name "Gaynellá") was indeed beautiful. Five years younger than James, she had delicate features, a graceful figure, and large, innocent eyes. There was a wistful quality about her that captivated more than a few men during her lifetime.

Gaynella was married when James Van DerZee met her, as was James himself, but each felt a strong attraction to the other. At first, they expressed it in harmless ways. "She liked to eat and I liked to eat. Lots of maids in the building would give me more food than I could eat, so I'd carry it down to the telephone operator."

THE PICTURE-TAKIN' MAN

He was in a mood to develop a friendship with a female. He and Kate were not getting along well at all. Kate was not happy about his venture into the photography business, even if it was only on a part-time basis. She wanted him to have a job that offered security, and photography seemed like just one more frivolous and financially unrewarding sideline. They were not seeing eye to eye on many other things, among them her habit of going away every summer. "I didn't really mind, but she'd say she would be gone for a week or two, and then she would stay and stay, and I wouldn't know when she would come back. She would want me to break up the flat and get a room. So one time I thought I'd put a scare into her. I said, 'Next time you go, don't come back.' And she took me up on it."

Actually, Kate did come back, but not for long. They were still living on 139th Street at the time; James was working nights one week, days the next. "Come a knock on the door and a man said he'd come to pick up things to go into storage. 'Go into storage?' I asked. Kate overheard. She said it was all right, she'd take care of it. I figured she just had some things she wanted to store. But I came home one day to find she'd packed up and gone. I felt kind of blue for a while."

After Kate left, James did not lack female companionship. He saw Gaynella every day at work. At other times, "different ones would come to my place and we'd have little parties and so forth . . . I seem to have a weakness for the feminine sex. I guess that's natural."

In fact, James Van DerZee had so much female company that after a while he lost his sadness and loneliness and started worrying. "I was afraid Kate *was* coming back!"

He did not stop missing Rachel. The beautiful child immor-

talized in his photographs remained dear to him. By the time Kate left, Rachel was about eight years old and had become quite a singer as well as something of an artist under James's tutelage. He kept paintings she had done as a child, packed away in one of his boxes. More than sixty years and countless moves later, he would still have them.

"Kate came back eventually, when the war started. She went to live with a girl friend of hers. Later on, one of the times she was down South, she got some kind of divorce. But before that I had to pay her forty dollars a month alimony. That became kind of monotonous." He and Kate would rarely see each other after the divorce. He would see Rachel on occasion, particularly after he remarried.

Sometime in late 1915 or early 1916, James Van DerZee lost his job at the Chatsworth Apartments. "I was on the passenger car. They had a service elevator there, too, and they had a boy for that. And the maids were supposed to go up and down on that service elevator. So one woman—her name was Mrs. Costigan—she had a habit of bringing her maid down on the passenger elevator. I told her I wasn't supposed to carry maids. Seems that's how I lost that job."

Losing the job was a serious blow to James because it meant that he and Gaynella would be unable to see each other every day under the guise of an innocent, working situation. He had fallen in love with her, although he had not yet admitted it to himself. She was understanding and supportive of his dreams. At the same time, she was very strong-willed. "She was under the sign of Taurus, and that seems to me a very powerful sign. She was very

THE PICTURE-TAKIN' MAN

persuasive, very persevering, and very beautiful. I thought it was quite unusual for such an attractive girl to be so versatile.

"I wasn't thinking about marrying anybody at the time. We went to the beach a few times; we had parties out there, lunches out there. Occasionally, we had boat rides up to Bryn Mawr and various places." Neither was free. He was still legally married to Kate, and Gaynella was still married to Charles Greenlee. Under the circumstances, there could be no thought of marriage, but James could not bear the idea of not seeing Gaynella, and they met as often as possible. Still, he missed seeing her every day, missed her so much, in fact, that he realized that next to her his other friends meant little. His decision to open an independent photography studio had more than a little to do with his desire to be with Gaynella.

James had grown tired of the arrangement with his brother-in-law under which Ernest paid him a weekly salary. "We were supposed to be in partnership, but I was making the pictures and he was getting the money. I saw I could do better with my own place. I decided I might try a studio for *myself*."

James told Gaynella about his hopes to open his own studio, and she eagerly encouraged him. "Gaynella was a go-getter. Whatever I mentioned, she was right behind me." He figured they could operate it together, and that it would be a perfectly respectable arrangement, since she was still married to Charles Greenlee. "In order to cover up for her, I let it appear that it was her studio and I was working for her. And one thing led to another, and the next thing I knew we were partners, partners for life."

James's decision caused some consternation to the Welcomes.

The photography business had been quite lucrative for them. They soon moved to a smaller house, a three-story brownstone at 451 Lenox Avenue, and Jennie later operated a photography business as a part of the Conservatory. Both the 1919 and 1919-1920 City Directories list under Photographers: "Toussaint Studio (Jennie L. Welcome), photos, 451 Lenox Avenue." But in James's recollection, photography was only a sideline for Jennie. "She was much more interested in teaching music and art." Around 1921, the Welcomes moved to Jamaica, Queens, where Walter lived. More blacks were moving into the area, and Jennie and Ernest successfully operated the Conservatory there. Ernest branched out again and established the Dunbar Realty Company. For a time, James would do some sales work for Ernest.

James's and Gaynella's Guarantee Photo Studio (they chose that name because James felt he could guarantee customer satisfaction) was located at 109 West 135th Street. A few years earlier, it would have been a far more risky venture than it was in 1915. By that time it had become customary for every important event and date to be recorded by a photographer. The average person still did not have a camera, and those who did rarely had the artistic eye necessary to produce a memorable record. On holidays like Christmas and Easter, people sought out professional photographers, as they did at graduations and confirmations. Parents wanted photographs of their children, girls wanted pictures for their boyfriends, families got into the habit of having a group portrait taken once a year. Aspiring entertainers wanted photographs for their portfolios, members of social and fraternal organizations wanted visual records of their annual reunions and special activities. There was all sorts of work for a professional photographer, and it was at that point that James decided defi-

THE PICTURE-TAKIN' MAN

nitely on his career. From then on, music would be a sideline and photography his business.

"I was on the ground floor, and I made pictures with electric light. Most of the studios in those days were top-floor studios, daylight work. And the mothers had to leave the baby carriages downstairs and climb all the steps up there . . . so the ground-floor studios became very fashionable. 'Course then they'd have to buy electric light, faster type lenses. But there was a great deal of business for the ground-floor studios.

"I had several studios. In some of them I'd use the Cooper Hewitt lights. In others I'd use the regular tungsten light. Cooper Hewitt is a blue light, all-purpose light, and it gives a very good soft effect, especially on white materials. On dresses it showed plenty of detail. The other lights were kind of hard and not so good. After the district began changing from DC to AC current, why, most everything was fluorescent lights, which were very good because they were less expensive, and you didn't have to worry about them blowing out—carbon light blew out very easily. All those photographic lights have changed over the years. Now they're making the faster films and also the faster lenses. So that helps a lot, too. A great deal of work can be done by existing light now."

Gaynella was the receptionist. "She used to take the orders in the office. But sometimes it would be necessary for me to be out of the office. She used to complain that I was always out. Now they tell me I don't go out enough. But I don't ever recall going out unless it was necessary."

When James was out and people came in and wanted their photographs taken, Gaynella would take them. "She'd tell me, 'Leave the plate holders loaded.' She was very good." One time

when James was out, Gaynella took photographs of some people who were struck by her beauty and decided she ought to be *in* pictures, not taking them.

According to James Van DerZee, the people were named Mandelbaum and they lived on Long Island. "They invited her out there one time for dinner. They wanted someone from Metro-Goldwyn-Mayer to meet her. He came all the way from California to get her to go into the silent movies at that time, but she was too much in love to be interested. She told them she'd let them know. They're still waiting for the answer! . . . Once in a while she used to tell me she wished she had gone. Of course at that time you didn't have to have any particular talent to be in the movies."

When James was out and Gaynella knew he was nearby, she would send for him. Across from the studio was a barber shop and one day James told Gaynella he was going over for a shave and a haircut. If anyone came in to be photographed, she should send a boy over to get him.

"I hadn't been there very long. The barber had just put the towel around my neck, when the door flew open. In comes this kid—I think they called him Hercules. He started running up and down the aisle, calling, 'The picture-takin' man here? The picture-takin' man here?'

" 'Yeah, yeah, yeah, Sonny,' says the barber. 'He's up in that chair over there.'

"Well, he comes up to me and puts his hand on the chair, crosses one leg over the other and looks up at me. 'Are you the picture-takin' man? Well, uh, uh, the picture-takin' lady said tell the picture-takin' man to come over to the picture-takin' place. Somebody wants their picture taken.'

THE PICTURE-TAKIN' MAN

"So after that everybody started calling me 'The Picture-Takin' Man.'" And that's how James Van DerZee was known in the neighborhood thereafter.

"Gaynella's husband was sickly and didn't live *too* long," according to James, and by the time Charles Greenlee died there was no question that James and Gaynella would get married. They were first married by a Justice of the Peace. Later, the two were married by a priest in St. Mark's Church on 138th Street.

James broke at least one heart when he married Gaynella. He kept two postcards that he received right after his marriage. The first was dated August 21, 1916: "Why bring the gladness to my heart then leave it in despair? Why bring the sunshine to my life, And then leave a shadow there? Love wasn't made to laugh at dear, why make a joke of mine? Hearts were not made to be destroyed, God made them too divine."

The second was dated August 24, 1916: "While you're living in the bright lights with the merry and the gay, There's a loving heart you've broken just to pass the time away."

Both were signed "R.O.H."

In March, 1917, the United States entered World War I, and a massive draft was begun to muster the necessary manpower for United States participation in the war in Europe. "They began calling this one, calling that one, calling the other one. First thing I knew, they were calling guys who had been dead for four months! I seemed to be the only one walking up and down the street who hadn't been called.

"I was Class 4-D, I think. There were A, B, C, and D classifications. They called the younger ones first and people who didn't

James Van DerZee holding a newspaper with World War I headlines.

Gaynella, about the time she and James fell in love.

have families. I was in my early thirties, and they were calling mostly men in their twenties. But I don't know why I wasn't drafted. I was strong and able-bodied."

James Van DerZee was not very concerned about the outcome of the war. "The less I knew about it, the better I liked it. But I wasn't much worried about it because the ocean divided us. We had a feeling of security over here."

James had no relatives or close friends in the fighting, but he knew many men who were drafted or who enlisted on their own. "Some of them came back and some of them didn't. I remember some of the boys talking about the way over there on the boat. One of them had never been on a boat before. And when they'd been out there a couple of days and all he could see was water, as far as he could see, nothing but water, he wanted to know how much water he was going to see. His friend said, 'Man, you ain't seen nothin'. You're just looking at the top.' The first guy said, 'Well, there's a little too much top for me!' "

For his part, James had no intention of enlisting. "*No thank you! No*body had done anything to me at *no* time. To go over there and look for a fight—that was not for me. This mother's child was not ready to be a soldier! . . . So I decided I'd better get myself a job a little more essential than taking these pictures. I got a job in an ammunition plant."

He still kept up his photography work, and U.S. entry into the war meant a considerable increase in his business. "The boys used to have their pictures made before they went over, and then their mothers and fathers and girlfriends would have their pictures made and send them to their boys. I made pictures of Needham Roberts [one of the first Americans to be awarded the French Croix de Guerre in the war]."

THE PICTURE-TAKIN' MAN

Soldiers and sailors flocked to the Guarantee Photo Studio, not just because it was accessible but because Van DerZee's photographs were so good. He took the same care with these photographs of young men going off to war as he did with his other photographs, took time to pose them, to get their natural expressions, to get the lighting just right. The resulting pictures were far more than visual keepsakes. They were portraits of young men who did not want to leave their families and friends but who had a strong sense of duty to their country. Their faces are proud and their shoulders are set, but their eyes convey some hesitation and the hope that they will return home just as soon as they are able. Looking at them, one could never guess how the photographer himself felt about the war.

"It wasn't long before the peace whistle blew, and I quit my job at the ammunition plant. I *flew* out of there, didn't even stop to pick up my pay." He returned to photography as a full-time business. The soldiers and sailors no longer beat a path to his door, but there was plenty of business in peacetime for a good photographer, and James Van DerZee's wartime photographs had established his reputation.

"I had as many white customers as black," James recalls. Although Harlem was increasingly populated by blacks, many whites still lived there. Over on Riverside Drive, on Morningside Drive, on Convent Avenue near City College, and on many brownstone-lined side streets, whites continue to live today. Back in the 1920s and 1930s, Harlem had a substantial white population. Whites from outside Harlem also came to James Van DerZee's studio because they had seen his portraits. And blacks and their institutions in Harlem provided plenty of business.

"I started doing a lot of work for the Catholic Church, made all

these different priests, confirmations, school graduations. My wife was Catholic, so I used to attend that church and do work for the church. Later on, I did all the big churches—Abyssinia, Mount Olive. Then there were the families, the children." Encouraged by Gaynella, James was devoting himself to photography nearly full time. There were no more elevator jobs. Occasionally, he still played music professionally. During one period, at night and on weekends, he played background music for the silent films at the Lincoln Theater. "Marie Lucas, the daughter of Sam Lucas, the comedian, was on the piano. I played first violin mostly, but during her lunch hour I would take over on the piano. And later on I played in the pit at the Lafayette Theater, replacing Miss Howie Anderson.

"The films were action films, somebody chasing somebody, a horse running away, something like that. They didn't always have themes and plots as they do today." He also played in the orchestra at the Apollo Theater, but by the early 1920s he had become "The Picture-Takin' Man" most of the time.

Fletcher Henderson, a black pianist who would pioneer large jazz orchestras, arrived in New York in 1920. In 1923 he formed his own band. Between those years, James Van DerZee played his last formal "gig" as a musician with Henderson. "It was a private affair—I forget who was giving it. Anyway, he was the pianist on the job. I guess that was about the last job I did. In the meantime, I used to teach music, little odd-and-end jobs, you know." And he continued to play once in a while. He would keep a program for "An Evening in Music" at Rush Memorial A.M.E. Zion Church, September 24, 1928, at which Mr. J. A. Vanderzee, of GGG Studio, is listed as performing a violin solo. But he decided it was unwise to go on with it seriously. "The progress became so fast. I

A bandleader.

Van DerZee recalls that this woman belonged to the Manhattan Elks.

Opposite: "Gypsy dancer," probably used later as a calendar photograph.

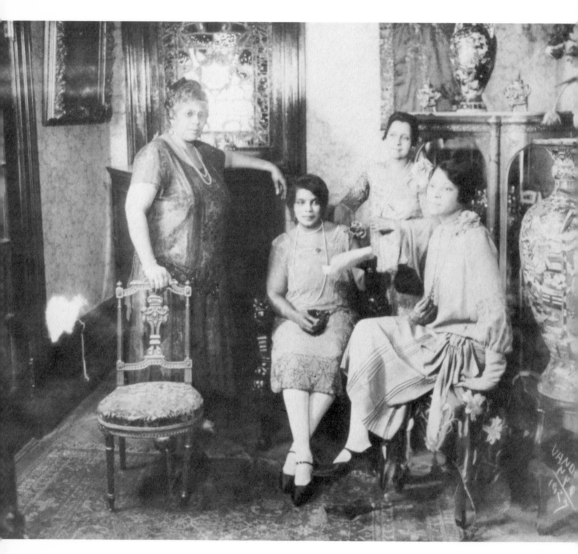

Harlem socialites at five o'clock tea.

The wife of the Reverend Becton, pastor of Salem Methodist Church.

National Convention,
Church of Christ, 1928.

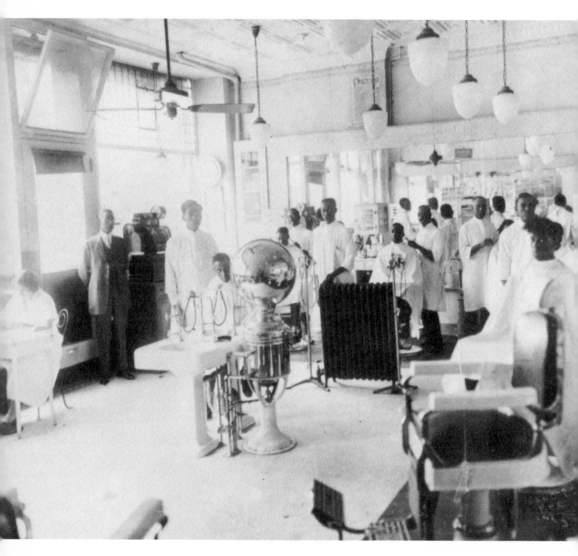

Harlem barbershop.

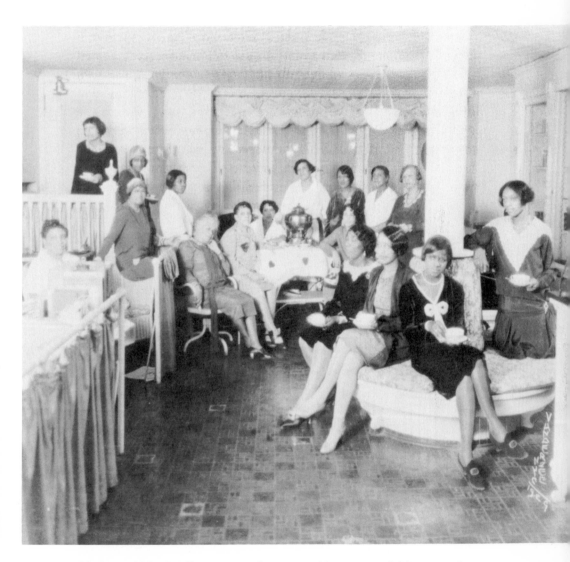

Madame Alelia Walker's tea parlor, part of her successful beauty salon.

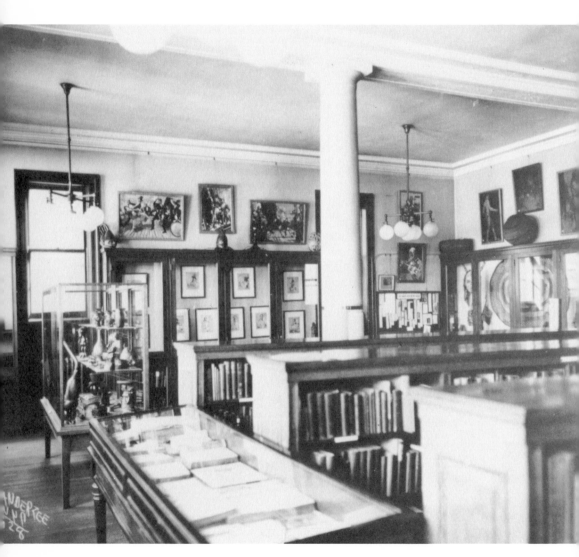

Schomburg Center for Research in Black Culture on 135th Street in Harlem, 1928.

can remember the time of the first phonographs, victrolas—we didn't have one when they first came out. We got one in the 1920s. It was a Victor. Paid two hundred and a quarter for it. A big speaker. You had to wind it up. Cabinet underneath to put the records. And a fellow told me the other day that they call them antiques now.

"There were so many mechanical instruments that it wasn't necessary to hire live music very often. When I started playing music, you could pick up an instrument and start playing and everyone would be looking and looking to see where it came from. After they started making radios and all those mechanical instruments, you could have a hundred-piece orchestra playing and no one would even bother to turn his head. I found that making pictures was more profitable than music—I had to eat three times a day, and in music sometimes I didn't work three times a week."

James made his decision just as opportunities for some black musicians in Harlem were reaching an all-time high, one that would never again be equalled. Had he been a different kind of musician, he might well have been able to make at least a modest living at it.

"After the war all these characters came from different parts of the Deep South and other places, looking for employment. That seemed to have changed the tide of things a great deal, because previous to that most everybody in Harlem knew everybody, and there weren't a lot of strange people in town." Although the majority of these new people who came north for jobs were laborers, among their ranks were a sizeable number of talented and creative people who were drawn to the place where the widest black audience could be reached. They were by no means the first talented blacks to migrate to New York City. Many educated black

politicians, businessmen, and artists had come during the years before World War I, drawn by the promise of greater opportunity and a more liberal racial atmosphere. But as more blacks arrived, so did the percentage of talented blacks. Langston Hughes was one. He became famous for his poems. His humorous stories about a black man named Jesse B. Semple have been translated into many languages. Other young writers who came to Harlem and later became famous were James Weldon Johnson, Jean Toomer, and Claude McKay. A young college football star named Paul Robeson arrived in Harlem around this time. The musical vaudeville team of Sissle and Blake arrived with the comedy vaudeville team of Miller and Lyles. The four men opened a black musical on Broadway in 1921, *Shuffle Along*, the first black show to run there since 1910. Florence Mills and Josephine Baker, two singer-dancers who later rose to stardom in Europe, were in that show. Many more artists, writers, singers, and entrepreneurs came to seek their fortunes in Harlem.

In even greater numbers came the black musicians, especially jazz and blues players from the South, attracted too by the concentration of black people in Harlem and the plethora of entertainment establishments that had opened to serve the growing population. Out of their coming together would arise the first New York jazz style. Influenced by musicians from New Orleans, Chicago, and Kansas City, where music was played in an ad-lib style instead of being written down, New York musicians began to improvise, and to create jazz.

The years 1920 to 1935 are called the Harlem Renaissance. It is a loose term, roughly applied to two distinct cultural movements, one literary and the other musical. Both developments owed much to whites. Talented blacks had been in New York for a long

time, but it took white interest to give their creative efforts status and publicity. The reason for the sudden white interest is suggested by one term, the New Negro.

The term *new* was applied to many things in the postwar period, and the generation of intellectuals and socialites that came of age in the 1920s was one that, according to historian Gilbert Osofsky, "discovered 'newness' all around itself—New Humanism, New Thought, New Women, New Criticism, New Psychology, New Masses, New Poetry, New Science, New Era, New Words, New Morality, and so on . . ." Most historians theorize that United States participation in an actual *world* war caused many Americans to become cynical about the world and its prospects for peace. Their lovely world had blown itself up and would never be the same again. Also, many artists, writers, and scholars were profoundly affected by the growth of industrialization, which preceded the war and then intensified to accommodate the wartime needs of the United States and its allies. Craftsmanship seemed to have given way to mass production. No longer was a worker responsible for the whole, finished product. Instead, he merely made one small part of it. The artists, writers, and scholars believed the coming of this "Machine Age" also meant the coming of a machine people, people who had less control over their own lives. A new economic order demanded new ways of looking at things, and in an atmosphere marked by an almost feverish casting about for ever more newness, the discovery of the New Negro was inevitable. In the minds of white intellectuals, bored white socialities, and generally antiestablishment types, the Negro represented the primitive innocence and life rhythm that white America had lost.

Meanwhile, the Negro had changed little. He had become a bit

more militant. Black soldiers and sailors had fought and died in strange lands to preserve for foreigners freedoms they did not themselves enjoy in their own country, and black people resented that. But basically, the Negro was just the same as he had always been. Any newness he had acquired was in the new eyes with which whites viewed him.

When the white literary world discovered the Negro, a generation of black writers was suddenly given the kind of support their forebears only dreamed about. White charitable foundations offered prizes for black literary efforts. White benefactors and benefactresses supported individual black writers. New literary magazines were born, established magazines were imbued with new vigor. The *Messenger, Challenge*, the *Negro World*, the *Emancipator*, and the *Crusader* provided a forum for black literary talent. Downtown white publishers caught the excitement and, beginning in the early 1920s, an unprecedented number of books by blacks were issued.

Among them was W.E.B. DuBois's novel *The Quest of the Silver Fleece*, and it may have been in connection with the publication of his book that DuBois came to New York at the time James happened to encounter him. It was on 135th Street, where James had his studio. Their conversation was brief and James's chief impression of the man who many years before had visited his aunts in Lenox was of "his bald head . . . and that goatee that he used to wear. I still see it."

Black music enjoyed a similar period of popularity, aided considerably by the passage of the Volstead Act in 1919 and the coming of Prohibition. Once the sale of alcoholic beverages was outlawed, illegal outlets for liquor opened up all over Harlem, many by gangsters to serve as places for their own brands of

THE PICTURE-TAKIN' MAN

bootleg liquor. Some of these establishments were lavishly decorated in jungle and Old South themes. They featured beautiful, light-skinned chorus girls in scanty costumes, and entertainment that emphasized Negro stereotypes like the grinning wisecracker, the sexy babe, and the frenetic dancer. Moreover, these speakeasies offered music in the new jazz style. Attracted by the prospect of exotic entertainment in the strange land of Harlem where the New Negro abided, the chance to be in Harlem but not of it, and the availability of illegal alcohol, white sightseers flocked northward. Harlem became the wild playground of New York, where the police looked the other way as liquor flowed, where young and old socialites rubbed elbows with some of the most notorious gangsters in the East, where the stars of Broadway relaxed after their own performances were over, where there was dancing and partying until dawn.

Many famous black musicians, singers, and dancers got their start in these clubs. Duke Ellington, Cab Calloway, Louis Armstrong, and Fletcher Henderson were the leaders of highly successful jazz bands. Lena Horne and Ethel Waters went on to have singing and movie careers. Bill "Bojangles" Robinson was a tap dancer, comedian, singer, and "born performer" who seemed to capture everyone's heart. He appeared in movies with Shirley Temple, starred in Broadway shows, and held the unofficial title of "Mayor of Harlem."

Given this new popularity for black music-makers, James Van DerZee might have been able to make his living at music after all, had he adopted the new styles. But he was not a fan of the new jazz. He favored more traditional music, and he was not alone. In June, 1921, J. Tim Brymn said in a speech before five hundred members of the Clef Club: "The different bands should follow

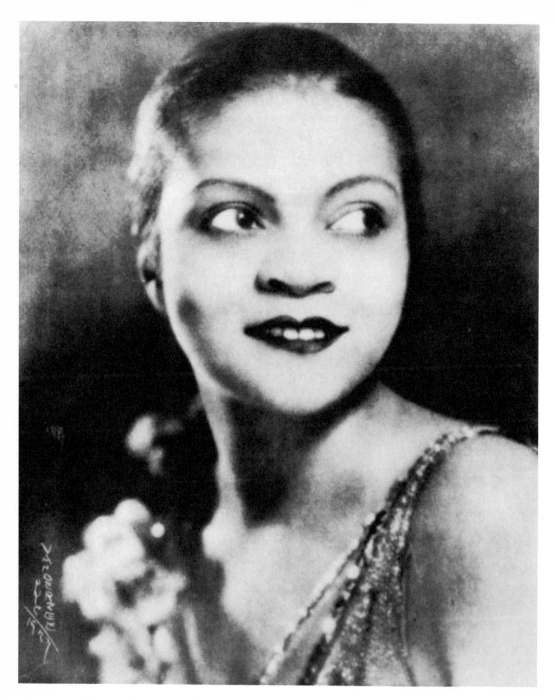

Singer Florence Mills, 1927.

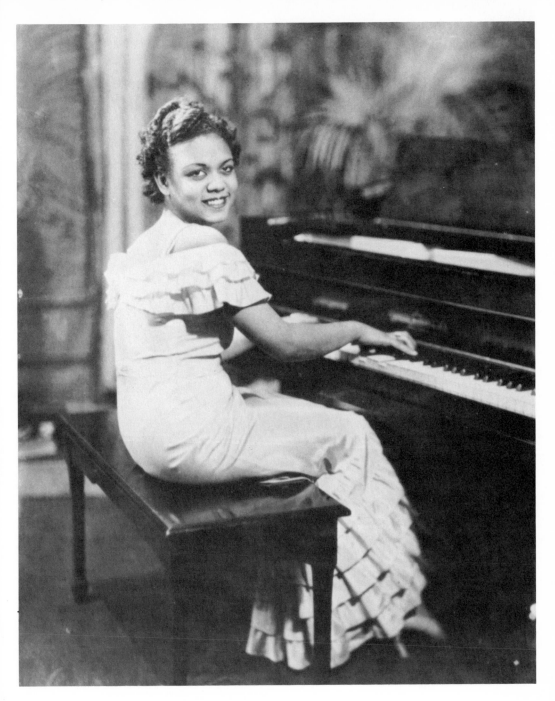

Pianist and singer, Hazel Scott, 1936.

Bill "Bojangles" Robinson, dancer and film star, with admirers in front of the YMCA on 135th Street. On his shoulders is Sunshine Sammy, a child star who appeared with Harold Lloyd in silent comedies.

A comedy team.

Joe Louis.

Jack Johnson, 1933.

Heavyweight boxer Harry Wills and wife at head of table. Host is
Jack Rose, restaurateur.

Daddy Grace in his heyday, 1930s.

their orchestrations more closely and not try so much of their 'ad lib' stuff. There is a growing tendency to make different breaks, discords, and other things which make a lot of noise and jumble up the melody until it is impossible to recognize it . . . If you find it necessary to improve on an orchestration have it done on paper so that the improved way of playing will be uniform and always the same."

James Van DerZee preferred music and audiences of a more conservative sort than the modern trend seemed to demand. "I liked to play waltzes, and the music they had in those days was altogether different. Everything in the days when I was learning music had some reason or meaning, some sentiment. Irving Berlin and Harry Von Tilzer, Victor Herbert—all these men. During those days they had dramatic experiences, and they wrote dramatically. But things started to change. . . ."

James would find it hard to adjust to the New York jazz style or to the music styles that came later, especially rock music. "Today it's just the beat . . . just pounding time, syncopation. You can't hum it, you can't sing it. I remember making pictures at a wedding one time. After the wedding I had to go over and make pictures of the reception. And they had that kind of music. And when I came out of there my head was jumpin', jumpin', jumpin'. Then I began to be glad that I hadn't kept up in the music business, if I had to play that kind of stuff." Things like reason and meaning and sentiment were very important to James Van Der-Zee. He found that he could express them directly in his photographs and be successful, but the time was no longer right to express them in music.

The social life of the Harlem Renaissance did not entirely pass by James Van DerZee. He used to play at some of the speakeasies

and noted the effects of the Volstead Act on some of his fellow musicians. "Some didn't even drink until after Prohibition. After Prohibition started, one particular boy, a very good pianist who never drank before, got so he drank so much we couldn't count on him for the orchestra."

He went to some of the big nightclubs—Small's Paradise, Connie's Inn—but he did not frequent such places—too many whites ogling blacks. He never attended the whites-only (unless you had connections) Cotton Club, although he did take pictures there on a couple of occasions. He photographed more often at the small, neighborhood speakeasies where blacks could have a good time away from the prying eyes of the white downtowners. While photographing at one such speakeasy, James got really drunk for the first and last time in his life.

The place, Charlie Thorpe's, was not far from the studio, so when James returned to the studio an hour late, Gaynella wanted to know why he had taken so long. Giddy from drinking, all James could do was laugh. "Well, I had to wait for the man to tell me when he wanted the pictures made!"

As Gaynella bustled about putting equipment away so she could close up, a woman entered from the street. "Do you sell locks?" she asked.

Gaynella was already exasperated with her husband. This woman was too much to take. "Look in that window," she demanded, pointing to the photograph display. "What do you see?"

"I see pictures," said the woman.

"Well, that's what we sell. We don't sell locks!" Gaynella cried.

The way his wife spoke to the woman struck James as funny. "Well, the woman wants a lock, let's sell her a lock!" he laughed. "Give her a lock, take one off the door!"

JAMES VAN DERZEE

Gaynella glared at him and at the woman, who quickly left.

At the time, they were living in an apartment in the same block as the studio. "Gaynella hustled me down the street and upstairs, and the way she was rushing me along tickled me. She got me upstairs and into the room and she started yanking off my coat and clothes. I said, 'Lord, I never been undressed so fast before in my life!' and that kind of amused her. I was acting so foolish, she started laughing, too!"

By the 1920s James had started using film rather than glass plates. "Plates are no good. You drop one of them and your whole career is gone, practically. And then, of course, they're very heavy. You get eight or ten of those things, you got all you can carry." He started using large-size film for his portrait work, smaller frame film for location shots.

He used a variety of cameras. "The ones I used most of the time were the Eastman Kodaks. I used several different types of lenses. I used a Wollensak lens for the portrait work, because it gives a nice softness and roundness without such extreme detail and doesn't require much retouching on the negative. For outside work, fast work, I mostly used the Graflex, the Press Graflex [a 5-by-7-inch camera manufactured between 1907 and 1923], and I had a couple of 35-mm cameras for parade pictures and that sort of thing. Because the other cameras had to have a tripod and all that sort of stuff, and that's not possible when you're trying to get an instantaneous picture."

In the early to mid-1920s he had occasion to use those 35-mm cameras often, for he was chosen as the official photographer for Marcus Garvey.

Garvey had been born in Jamaica in 1887. As a young man he

had felt keenly the exploitation of blacks under European colonists. In 1907, he was involved in the unsuccessful Printers' Union strike. He helped to form the first political club for Jamaican blacks, the National Club, and the club's publication *Our Own*. He traveled to Panama, to Equador, and to South America, where West Indian labor was being used in the tobacco fields and in mining. Everywhere he went he saw his people laboring under terrible conditions. He started first one, then another, newspaper to expose the injustices he had seen, but the people were disorganized and the government was disinterested. He went to London in 1912, and under the tutelage of Duse Mohammed Ali, Egyptian scholar, traveler, and publisher of the London-based *African Times and Orient Review*, learned about Africa's ancient civilizations and learned as well that three-quarters of the world's population was nonwhite. He arrived back in Jamaica on July 15, 1914, and within five days had founded the Universal Negro Improvement Association (UNIA) to unite "all Negro people of the world into one great body to establish a country and a government absolutely on their own."

Garvey went to the United States in 1916, hoping to secure funding for a school in Jamaica. He found United States blacks much interested in his ideas and plans. Many Harlem blacks were ready to follow a man who preached nationalism and moving "Back to Africa." Garvey decided to stay in the United States for a time. He founded a branch of the UNIA and established a paper, *The Negro World*, which was published from 1918 to 1923. By 1919 there were branches of the UNIA throughout the world, and in August, 1920, Marcus Garvey presided over "The First International Convention of the Negro Peoples of the World" in Madison Square Garden in New York City. Attended

by well over twenty-five thousand, the thirty-day convention was the first occasion on which representatives of African people around the globe met in sessions to discuss social, economic, and political conditions and ways to remedy them. Garvey organized the Black Star Line, a steamship company for transporting cargoes of African produce to the United States. On their return voyages, the ships would carry blacks back to their homeland.

Garvey was an organizational genius. Announcing that the basic governmental structure for the new African nation would be established first in the New World, he accorded himself and his aides titles, established a uniformed corps (Elijah Muhammad, founder of the Black Muslims, and Malcolm X's father were members of the corps), and a similarly uniformed women's auxilliary corps. Impressive parades were held in Harlem, attracting thousands to the cause, and by 1926 Garvey's power was sufficient to constitute a threat in the eyes of the U.S. government. Charged with misusing the mails in connection with the sale of stock in the Black Star Line, Garvey was deported to Jamaica, where he died in 1940.

During the twenties, many blacks and whites considered Garvey a fraud and a charlatan. Half a century later, however, with the resurgence of interest in black nationalism, Garvey began to be viewed with a new respect by both blacks and whites. Today, he is considered a pivotal figure in the history of the black urge to self-determination, and James Van DerZee's photographs of Garvey and his movement are valuable historical documents.

"His headquarters was on Seventh Avenue only a couple blocks away from my studio. Some members of his organization approached me and asked me if I'd take pictures of their parades and functions. They'd notify me when he was coming. They'd say

Marcus Garvey (in plumed hat), 1924.

Overleaf: Marcus Garvey on the reviewing stand.

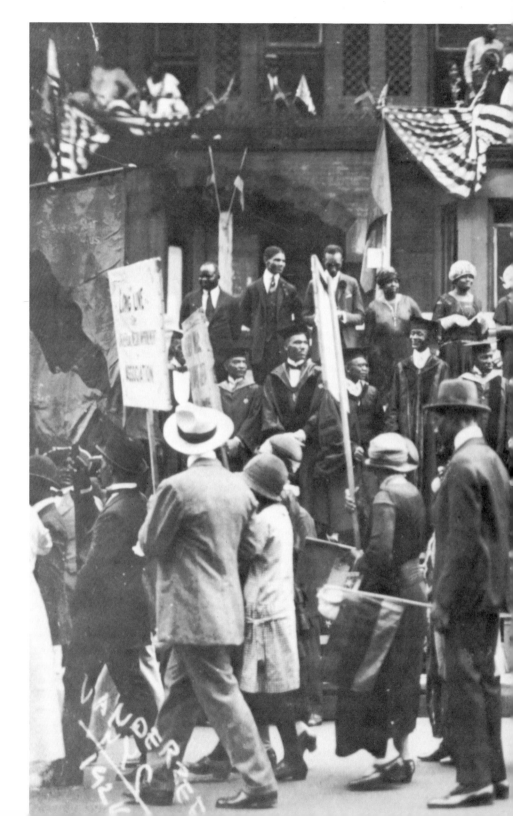

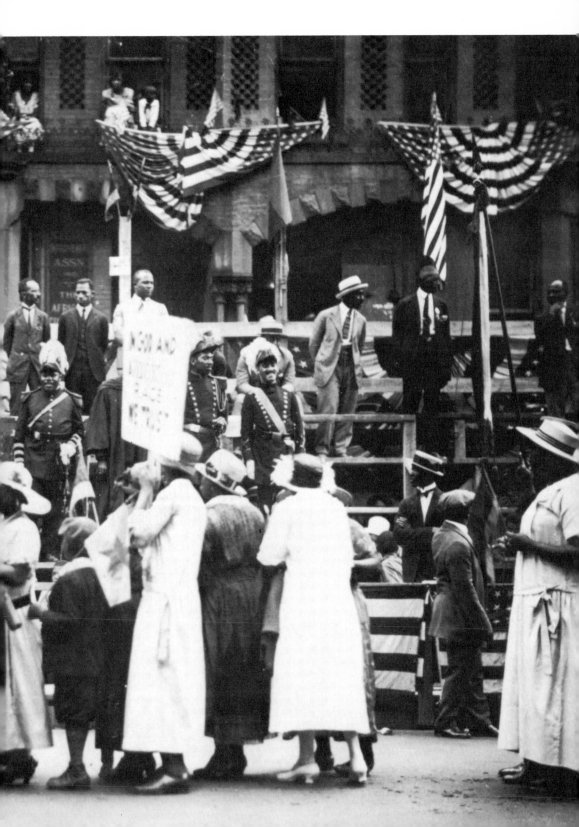

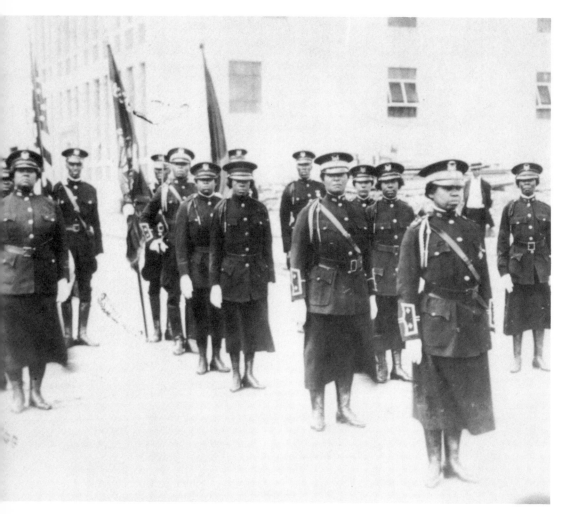

The women's corps of Garvey's African Legion.

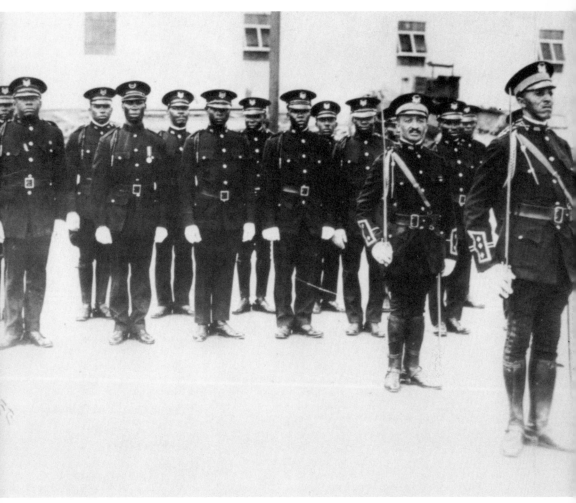

Marcus Garvey's uniformed guards, part of his African Legion.

The *Yarmouth*, one of the ships in Garvey's Black Star Line.

there was going to be a parade at such and such a time and they'd like some photographs made.

"I'd go and make the pictures and take them over and they'd pick out the ones they liked. They wouldn't prevent other photographers from taking pictures, but there weren't all these street cameras in those days like there are today. I was usually the only one photographing.

"They'd use the pictures for their newspaper, *The Negro World*, and they'd use them for out-of-town publicity. And a great many of the members would want to buy pictures."

James Van DerZee photographed Garvey in his impressive uniform, surrounded by bodyguards, riding in an open car through the streets of Harlem; he photographed the parades, the building that housed *The Negro World*; he photographed one of the ships of the Black Star Line, Garvey's wives, and Garvey's meetings; but he never got caught up in the Garvey movement.

"His meetings were widely attended, and he was very influential and had a great many followers. His death seemed to be very untimely and very much regretted by his followers. I was in the course of making some pictures of Mrs. Garvey, who was writing a book on his life, and she died a bit before it was completed.

"Now it seems that Marcus Garvey's coming back again. Everybody wants to hear about him and his purpose and what kind of a speaker he was. But I never attended any of the lectures or any of the meetings. I used to go there and make the pictures. And as soon as I accomplished what I came there for, I was out and back to the studio."

Maddening for historians. Here was a man who had been official photographer not just for Marcus Garvey but for other important figures in Harlem as well. There was Father Divine, who

had come to public attention in Harlem in 1933, when the Renaissance was ending and the Great Depression had begun. Many Harlemites were hard-hit by the Depression, unemployed and destitute, and they turned to this charismatic figure who claimed he was God reincarnated and who established "Kingdoms of Peace" to house the homeless and feed the hungry. He became so powerful that white political candidates sought his support in their bids for office.

There was Daddy Grace, who also came to prominence in 1933 and who was a rival of Father Divine's. He claimed to be able to make the blind see and the lame walk. He established a following all along the East Coast and was more popular with Southern blacks than was Father Divine.

James also photographed Florence Mills and pianist Hazel Scott, the first Mrs. Adam Clayton Powell, Jr., and Bill "Bojangles" Robinson. "Bill Robinson was just getting popular at the time I started making his pictures. His life was beginning to get more colorful and meaningful to him. He was a very good dancer, and I believe Shirley Temple learned quite a bit from him. She was one of his dancing protegés."

Baseball player Satchel Paige and boxer Joe Louis, Adam Clayton Powell, Sr., and Adam Clayton Powell, Jr.—he photographed these and a host of others, and yet he would come away with no inside stories to tell, no previously unknown facts to reveal. He simply "made his pictures and left."

"I had an assignment to make the job, I'd make the job, and I'd be gone. That was it. Almost all the jobs I got, I got paid before I went. Sometimes they'd give me a deposit, come and pick up the pictures, pay the balance. I did very little speculative work, only on Elks' and Masons' parades and that kind of thing." He was

THE PICTURE-TAKIN' MAN

making his living at photography; film and materials were expensive, rent on his studio was due every month; he and Gaynella had to live. He made photographs on demand and on assignment and sold the results to the people who paid him. It was not necessary for him to get their history.

"When you make pictures for newspapers, you have to get some history and you become more personally acquainted with them [subjects]. I didn't do that. The boys of today, they get a story on the whole thing. They do a lot of speculation work for newspapers and they have to know what it's all about. Today there's so many photographers. I don't know how they make a living."

Unlike today's photographers, James Van DerZee shot no multiple pictures, produced no reams of contact sheets on the same subject. "I made one picture and that was it. You didn't shoot any thirty or forty to get one, like some of these photographers do today. I made just what I wanted to use and that I thought I could sell."

James Van DerZee had no intention of becoming an historian of Harlem, or an historian of America during the period of history when he was active as a photographer; or of doing a book; or even of becoming a press photographer—not that there was much opportunity for newspaper work for a black photographer anyway. But as he grew old and his contemporaries died, after he was "discovered" in the late 1960s and came to be known as one of the oldest photographers in the United States, the fact that he had lived so long became something of a liability. Along with the pain in his legs and his lack of strength and his day-to-day loneliness, he was faced with the burden of being one of the only men alive who had seen ninety-odd years of life as a black man in

America. Having lived so much history, he was expected to re-
member it all, and in detail, and in a variety of political, social,
and philosophical contexts.

How many of us remember distinctly each of the Apollo mis-
sions, the ramifications of color television, the conversation—
verbatim—we had with the last famous person, or potentially
famous person, we met? And how distinctly will we remember
them twenty, thirty, forty years hence? James Van DerZee has
provided us with a detailed visual record, more accurate than
memories, of the eras through which he lived. More importantly,
he has extensively recorded an aspect of black history that has
gone largely unnoticed, indeed, one of which most people, black
and white, were almost completely unaware until his photo-
graphs came to the eye of the general public. It was what so
excited Reginald McGhee, the young photographer engaged by
the Metropolitan Museum of Art to find photographs for its ex-
hibition "Harlem on My Mind." In addition to the photographs of
luminaries of the Harlem Renaissance, James Van DerZee had,
while in the course of "doing his job," collected a staggering
amount of visual documentation of what might be called the
"other Harlem."

All through the Harlem Renaissance and the Great Depression
that ended it, that "other Harlem" existed, though few outsiders
took any notice of it. While Duke Ellington played and Langston
Hughes published, the ordinary people of Harlem, those who
were not particularly talented in music or literature or dancing or
acting, went to their lodge meetings and their beauty parlors, had
their teas and joined their civic organizations. While singer Billie
Holiday succumbed to drugs and writer Wallace Thurman drank
himself to sleep, the ordinary people of Harlem went to church

and, on occasion, dressed up in their finery and visited a photographer. During the Depression, while thousands stood on bread lines, thousands of others somehow managed to make ends meet. While many unwittingly became statistics in later sociological studies on the fatherless black family, many more families stayed together and proudly had their pictures taken at James Van Der-Zee's photo studios.

"In [these] photographs," wrote Reginald McGhee about James Van DerZee's work, "you will not see the common images of black Americans—downtrodden rural or urban citizens. Instead, you will see a people of great pride and fascinating beauty."

That these men and women, these families and children, emerge in James Van DerZee's photographs as almost uniformly attractive, dignified, and prideful is a tribute to themselves and to their photographer. Though they were hardworking, upstanding, and upwardly mobile, they were, in reality, not without flaws. James Van DerZee unabashedly took away the flaws, or at any rate many of them. "Being an artist, I had an artist's instincts. Why, you have an advantage over the average photographer. You can see the picture before it's taken; then it's up to you to get the *camera* to see it."

6

James Van DerZee:
Artist and Photographer

"James Van DerZee: Artist and Photographer." That's how he advertised, although he neither drew nor painted pictures. He practiced his artistry on his 8 by 10 film plates, touching up here, removing a wrinkle there, combining two photographs so that one served as a backdrop for the other. He practiced his artistry in the way he positioned his subjects, in the kinds of backgrounds he arranged for them, in his use of lighting. He took whatever license was necessary to produce on photographic paper what he saw in his mind's eye, happily unaware that what he was doing had been a subject of violent disagreement since the first days of photography. Had he known about the disagreements, he probably would have pooh-poohed them anyway. To James Van Der-Zee, photography *was* art. He'd taken it up in the first place to "get away from all that drawing and painting."

In his drawing and painting days, he had envisioned his pic-

ARTIST AND PHOTOGRAPHER

tures but been unable to create on paper what he saw in his mind's eye. With photography, he was able to recreate his mental images. Just as the artists who used the camera obscura did so because it freed them from the laborious rendering of proper perspective, so James Van DerZee used the camera as a valuable tool toward a greater end. Shooting the picture was the least important step in his creative process. He exercised his artistry in what he did before the photograph was taken, and in what he did as he processed the negative and the print. Naturally, he considered photography an art, and though he was without outside influence in his thinking, in the larger world he was not alone.

Ever since the invention of the daguerreotype, there had been controversy in intellectual and artistic circles regarding the proper relationship between photography and painting. For a time, in the mid-nineteenth century, photography had practically supplanted miniature painting and exerted such a strong influence on painters of large portraits that many, like Charles Willson Peale, incorporated in their work the stiff poses, harsh lighting, smoothly graded tones, and monochromatic color schemes of photography.

Simultaneously, people who considered themselves authorities on photography were urging photographers to imitate the techniques of painters. In 1869, Henry Peach Robinson, a professional photographer who had been trained as an artist, published what might be called a rule book for photographers. *Pictorial Effect in Photography* advised photographers to use models and artificial backdrops, to arrange their models in pyramidal compositions, and to balance the proportions of light and dark, as painters were supposed to do. Not only did Robinson assume that the rules set up for painting could be applied to photography, but also he

assumed the rules for painting were unbreakable. Modern paint-
ing would prove him wrong.

There were many who disagreed with Robinson and his sup-
porters. Some of his critics believed that because photographs
were at least based on reality, no matter how much composing
and retouching was done, they could not be considered entirely
creative works. These same people had criticized Robinson in
1858 when he produced a five-negative print called *Fading Away*.
The subject was a dying girl surrounded by family mourners. The
girl in the photograph was a model, so she was not really dying,
but the critics still said the subject was too painful to be repre-
sented by photography. If Robinson had painted the same scene,
using the same models, the work would not have been criticized
for portraying so depressing a subject.

Then there were the people who thought retouching was ac-
ceptable but that it should not be extensive; otherwise, a pho-
tograph would be merely a poor imitation of a painting. Some
authorities on portrait painting hastened to set up guidelines for
portrait photographers, stipulating just how much retouching
should be done on the various parts of the face and body.

Though the controversy raged primarily in Europe, it echoed
in the United States and intensified there when Edward Steichen
and Alfred Stieglitz met in New York in the early 1900s. Steichen
was born in Luxembourg in 1879, but his family immigrated to
the United States and settled in Hancock, Michigan, when Ed-
ward was three years old. His original training was in painting,
and his early photographs show this influence. He frequently
"tampered" with his photographs, brushing on silver salts and
other chemicals to eliminate or add images. Stieglitz was born in
Hoboken, New Jersey, in 1864, went to Berlin to study mechani-

cal engineering and there discovered photography. He returned to the United States in 1890, determined to advance the cause of photography as art. Although he was a purist who did no retouching, he believed other photographers were completely justified in doing so, if they wished. In 1902, Stieglitz invited Steichen and eleven other photographers to found an organization devoted to promoting photography as a fine art. By this, they meant that it did not have to remain a craft that imitated painting by recording and increasingly embellishing similar subject matter. They believed that photographs of ordinary subjects and everyday scenes, printed without any retouching, could have as valuable and as genuine aesthetic appeal as paintings or photographs that had been painstakingly retouched. If the moment of shooting was sensitively chosen, the lighting and angle of vision thoughtfully considered, a photograph of poor Europeans in the steerage section of a ship bound for America could have as much artistic value as a painting of a Biblical scene or as Robinson's *Fading Away* with its five different negatives and retouching.

The organization, which was called the Photo-Secession to indicate a revolt against traditional concepts, founded the magazine *Camera Work* in 1903, and opened a gallery in 1905 that, true to the Photo-Secessionists' opinion that photography laid claim to a rightful place beside fine art, became one of the first galleries to exhibit modern art. Both the magazine and the gallery succumbed to difficulties brought on by World War I and came to an end in 1917, but the organization is given considerable credit for making photography the vigorous art it is today. Although the process of retouching lost favor and the concept of "previsualization"—the consideration of all values and textures *before* the release of the shutter—became the accepted practice, there

would remain among many artistic photographers and critics a respect for masters at retouching, such as Steichen and, much later, James Van DerZee.

James was once asked what he thought of Steichen and Stieglitz. "Who are they?" he responded simply. He had never heard of the Photo-Secession, never seen a copy of *Camera Work*. He did buy photography magazines and forty years later would still have them stored in boxes, but, "I read them mostly to keep in touch with the latest equipment. I never learned anything from them." He had been calmly oblivious to all the controversy, and so it didn't occur to him that it might be wrong to make a picture look the way he thought it ought to look. If he had had the means, and if the racial situation had been different, what a killing he could have made among the wealthy on Park Avenue!

His primary business was portraiture. Given his locations and the prices he charged, he could have taken less care, had more sittings in a day, but he was a perfectionist. "Time I'd made three, four sittings in one day, I was tired. I had to position them, set each face. Actually, the light's very important. Couldn't make everybody in the same light and be successful. Sometimes, under certain lighting, you see certain characteristic effects, but when you get them back in the studio and turn on your lights, all that is gone. You've got to rearrange the lights so as to bring out the character and personality and distinctions, and get the best expression and start from there."

Because he considered himself an artist, he took the trouble he did out of pride. But if he had not cared about his subjects, his photographs would not have been as successful, no matter how skillfully he employed light and shade or wielded his etching knife and retouching pencil. James Van DerZee liked people. The

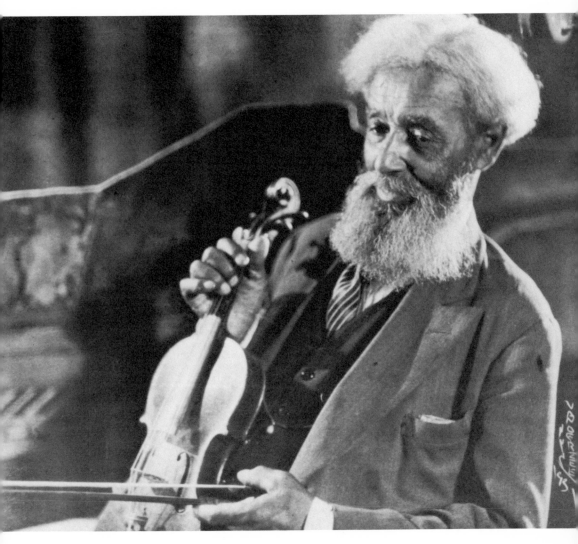

Van DerZee liked this model and posed him with his violin.

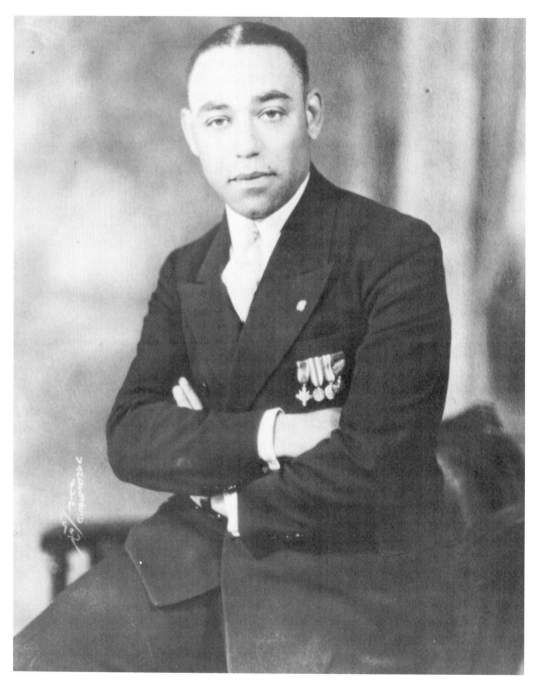

Needham Roberts, one of the first Americans to be awarded the French
Croix de Guerre in World War I.

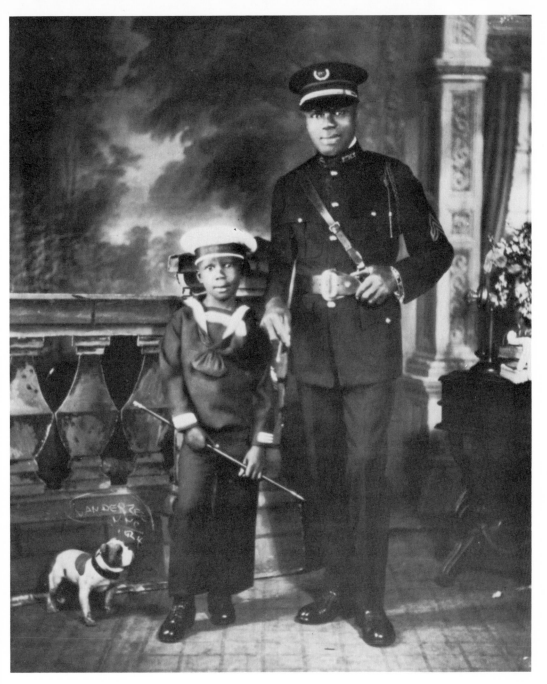

A proud father in the African Legion uniform (Garvey's corps) poses
with his son.

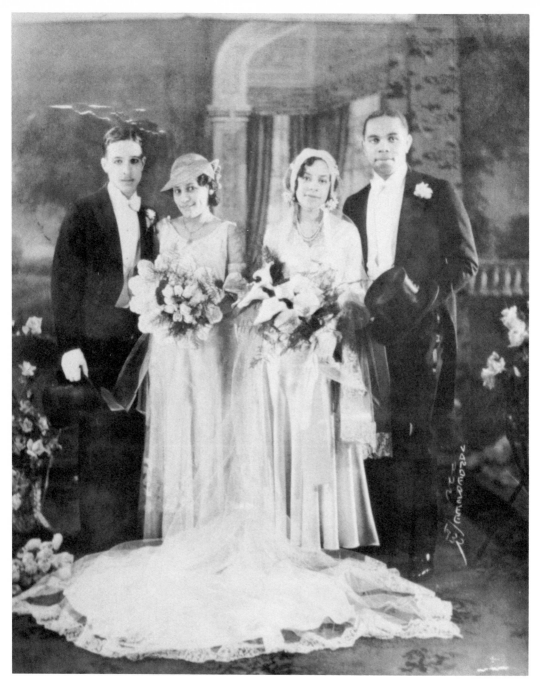

Wedding photographs were always an important part of Van DerZee's business.

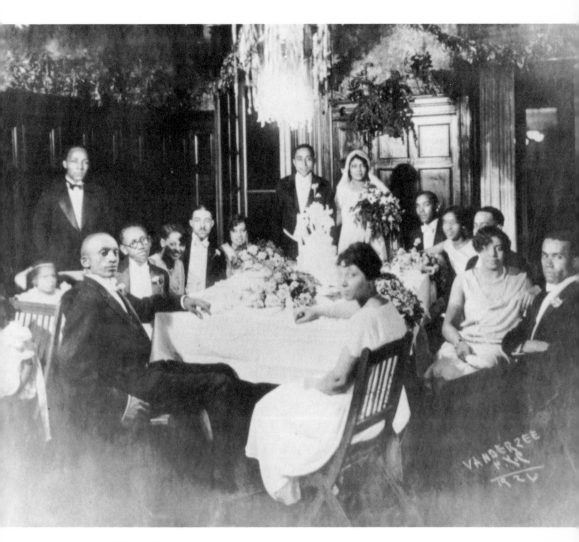

A wedding dinner.

"Tom Thumb" mock wedding, probably a calendar photograph.

affection he had known as a member of the Van DerZee and Osterhout enclave, and his happy childhood in Lenox, had nurtured a tolerance and respect for his fellow man that would never leave him. He believed that there was beauty in life, beauty in people, and that through photography he was able to reveal it.

James always insisted that he could even see beauty that didn't exist. "Somebody would come in and say, 'I never take a good picture.' I'd say, 'Why not? You've got two eyes, a nose, and a mouth like everybody else.' There might be some difference in the shape of the features. With some of them, you'd put the light on and their nose seemed to go to one side. You'd have to arrange the lights. With some people, one side of their face seemed to be a little bigger than the other. All that is immediately noticeable to the artist."

Much of his creative work was done on the negatives. "With the large-size film, I could do a lot with an etching knife and a retouching pencil. I paid attention to the face, I appreciated the face."

Back in Lenox, drawing and painting on winter evenings with the family, James had preferred landscapes because he had not been able to get faces to look the way he had wanted them to. With his unretouched negatives and his retouching tools he could. "You can see what lines aren't necessary, and you know if you are making a certain type of face what lines to put in there. Some [photographers] would take out *all* the lines and the faces would look just like billiard balls. If it wasn't beautiful, why I took out the unbeautifulness, put them in the position that they looked beautiful, took out the defects, pulled out all those sagging muscles. Some of them looked like they were worried a lot. I'd pencil them up, take out some of those wrinkles and lines, soften

the eyes if they were hard. If they had cross-eyes, I'd straighten them out. If they had gold teeth I could lighten them up. Hair was thin, I'd thicken it, restyle it sometimes."

In those days, there were professional retouchers who went around to the various photographic establishments. James Van DerZee would have none of that. For him, retouching was one of the most satisfying parts of portrait photography. He proudly claimed that he could make a good picture of just about anybody.

"I *said* that, but one time I looked out the window and saw a woman coming across the street and I said to myself, I don't know *what* I would do with *her*! Sure enough, she came right into the studio, came in there with a face that looked like cracked ice! I took out some lines, left in a few characteristic ones—I couldn't take out *too* many lines or it wouldn't look like her at all. She went out happy. I never had anybody who didn't like the pictures.

"I do recall one girl saying, 'Can't you make no pictures that look like me? I'd hate for people to say they were nice pictures but I don't look like that.' I said I could make such pictures and showed her the proofs. 'But the proofs look so *bad*,' she said."

He always liked photographing women and children best. "Men, they all looked the same. All wore practically the same clothes. Women, they could change their hair in different styles, make different types of pictures. Children were never the same twice! They were just more interesting."

Although children can be the bane of a portrait photographer's life, James never had any trouble. He liked children and took time to put them at their ease, sometimes despite the anxious ministrations of their parents. "We photographers have a way with children," he would assure the parents with a twinkle in his

eye, remembering a story once told to him by a photographer friend.

"An aunt brought her nephew into the studio, and she was very fussy, fixing the kid's bow tie and all, promising everything from lollipops to popcorn to a ride on the merry-go-round if he would sit still. The photographer got tired of this woman fooling around with this kid and trying to get him to pose right. So he said to her, 'Madame, I think if you step outside I'll be able to take the boy's picture.' She stepped outside. Two minutes later he comes out with the boy. As they're going out, the aunt asks, 'Johnny, what did he promise you?' Johnny says, 'He didn't promise me nuthin'. He just said, Set up there, you son of a gun, or I'll knock your brains out!' "

James Van DerZee found the surprise tactic very effective with children. "I'd give them a touch that they didn't understand, that didn't seem altogether friendly to them. Then they'd shape up, you know, and look at me wondering, Did he know how tight he grabbed my shoulder? I'd pretend to ignore it. After that, I wouldn't have any trouble.

"I remember the last picture I took of a kid. He was pretty good out in the office. His mother had him all dressed up in a nice little cutaway suit. She wanted Easter pictures made. When the kid came in the back, why he decided he didn't want any pictures made; he began to get kind of rebellious. She tried to talk to him, and I said to myself, Well, if she can take it, I can take it. Finally she lost her patience. She said, 'Oh, I don't care how he looks, take him anyhow!' So I took him with his mouth wide open—Waaaaahhh!—and I put some notes out in front there by his mouth, like he was singing. She liked the picture very much, thought it was a cute idea."

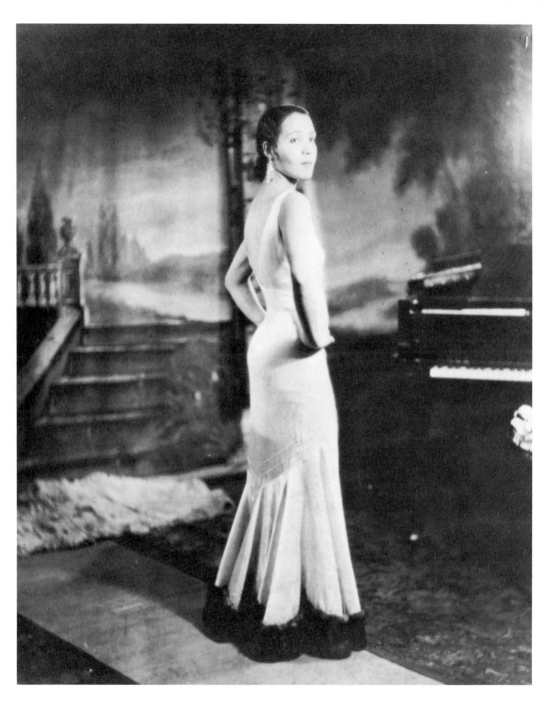

A fashion model.

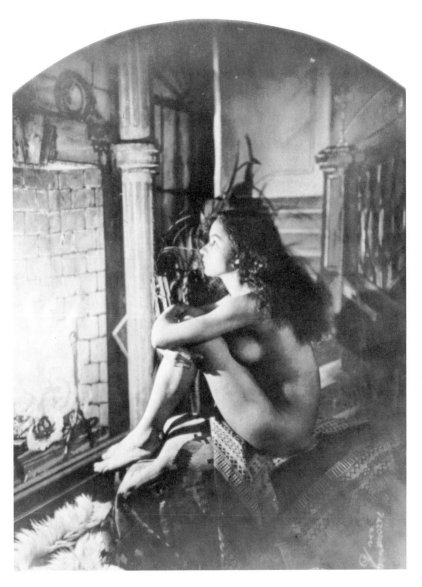

One of Van DerZee's nude studies, done as a possible calendar illustration.

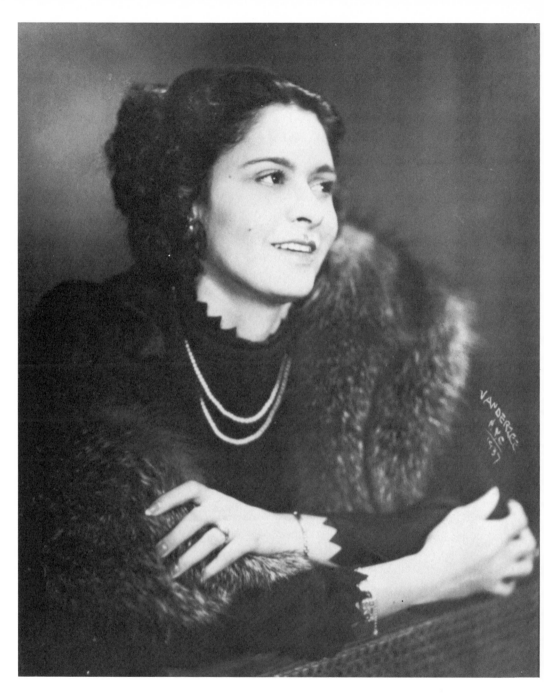

A Harlem beautician.

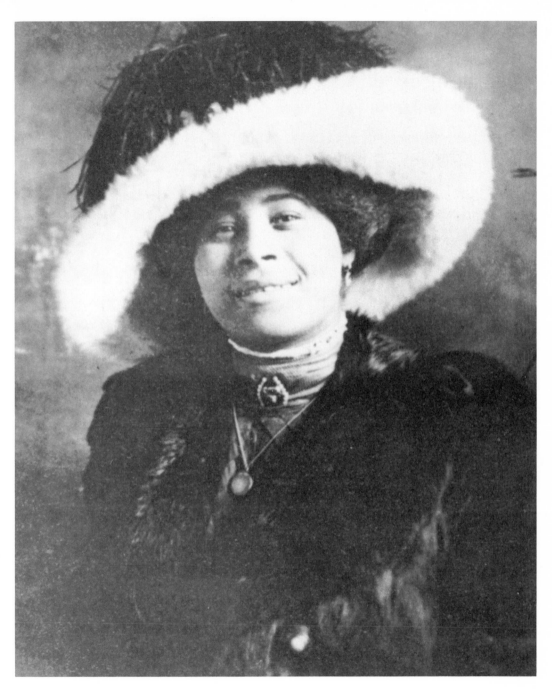

Rosalee Capers, one of Van DerZee's friends.

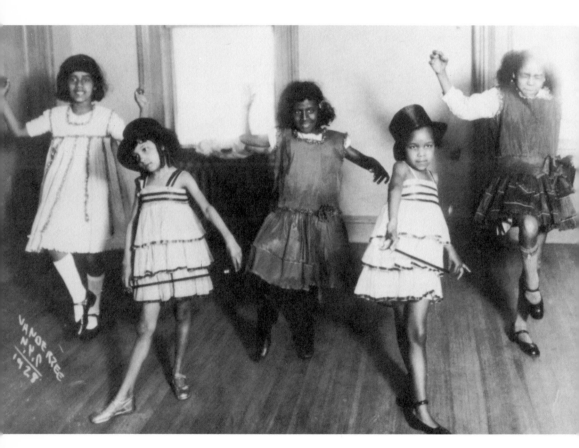

Star pupils (and one spoiler) at a Harlem dancing school, 1928.

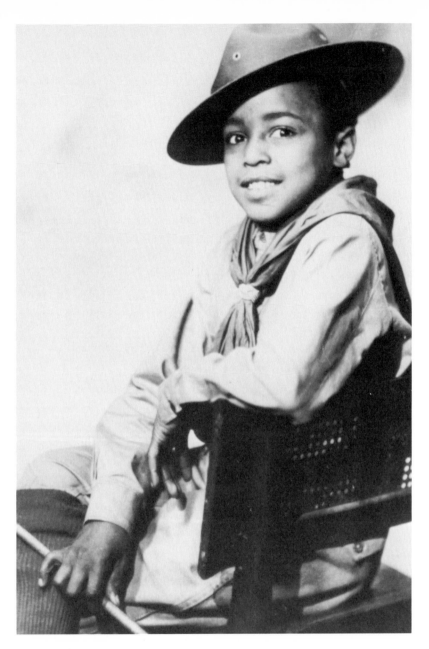

A proud boy scout.

JAMES VAN DERZEE

James Van DerZee enjoyed making pictures that told a story, and often he would ask his sitters to assume poses before appropriate backdrops in order that "they would appear to be doing something, not just sitting there posing for a picture." Thus a family group is arranged so that the two small children appear to be playing a duet on a piano while their proud parents look on, a little girl appears to be turning away from a radio to report what she has just heard, a woman in evening dress turns from the piano to look at someone outside the photograph, but her sensual look and the objects in the foreground—a pipe in an ashtray, a can of tobacco—indicate the presence of a man.

His photographs of soldiers going off to World War I were among the first in which he told a story, and he continued to use that style throughout the 1920s. There is a particularly fine photograph of an elderly man seated before a fireplace next to which is an American flag. The man appears to be asleep, and his dream, a battle scene, is shown at one side of the picture. James Van DerZee took the photograph in 1921. He called it *Memories*. To accomplish it, he used multiple-image techniques, achieving them through double printing. He first printed the negative of the old man, then reprinted it, adding the battle scene that is supposed to be the subject of the man's dream. It was the same technique Henry Peach Robinson had used in *Fading Away* and it had first been used in American photography as early as the 1840s, but James Van DerZee was totally unaware of previous efforts in the technique.

"I hadn't seen other photographs like that before I started doing it. I guess it was just a matter of not being satisfied with what the camera was doing. I wanted to make the camera take

what I thought should be there, too. I wasn't satisfied with just the people's picture. I wanted to see if I could incorporate what they were thinking about, and that [multiple-image technique] was my way of doing it. It wasn't difficult with the proper facilities, and when I had my own studio, I had those facilities."

James knew other photographers in Harlem, but he does not recall ever learning anything from them. "I usually just saw where I could improve on the things they did. There was one boy in particular, though, who was an artist and a photographer and that was an advantage. He could make backgrounds, not just on the wall but on negatives. Eddie Elcha. He painted some of the backdrops for my studio.

"When it came to photography, I can't recall ever trying to do anything I couldn't do, but at the same time I was never satisfied. I was always trying to do better. I didn't know I was doing things so well!"

Nowhere was his concern with telling a story more evident than in his funeral pictures, which were very popular during the 1920s and 1930s. People did not have as many photographs of their loved ones as they do today, and when loved ones died, it was customary to have a funeral picture taken so that those who survived would have a way to remember how the dead person looked. Small children were the most common subjects of funeral pictures. As James explains, "In some cases, the mother would never have even seen the child if it hadn't been for the photograph. Perhaps she was seriously ill at the time of birth and the child was stillborn or something.

"I made a great many funeral pictures. I always tried to insert something to break the gruesomeness of the picture and make it

JAMES VAN DERZEE

look more like the realities of life and the beauty of death. According to the scripture, we should be more joyful at the going out and weep at the coming in.

"I remember one woman whose baby died when he was a year or two old. He had a little toy dog and a teddy bear and a tin soldier. When I made the pictures I had the undertaker lay him out on the couch, and I put a little electric light bulb in his hand—it looked like a ball—and beside him his teddy bear and soldier. Then below it I put a little verse. I don't know where I learned it or heard it, but I printed this little verse below on the picture [his memory of "Little Boy Blue" by Eugene Field]:

> The little toy dog is covered with dust,
> The little tin soldier is red with rust,
> And his musket molds in his hand.
> But the time was when the little toy dog was new,
> And the soldier was passing fair,
> But that was the time when the little boy blue
> Kissed them and put them there.
> "Now don't you go till I come," he says,
> "And don't you make any noise."
> So toddling off to his trundle bed,
> He dreamed of his pretty toys.
> So while he was dreaming an angel saw him,
> Awakened the little boy blue,
> And the years are many and the years are long,
> But the toy friends are true.
> But they wonder, waiting the long years through
> In the dust of that little chair,
> What has become of the little boy blue
> Since he kissed them and put them there.

ARTIST AND PHOTOGRAPHER

She liked it so much. She thought it was so nice." For another funeral picture, he had a verse from the sheet music of the song "Oh Promise Me" printed beneath the picture.

He had photographed funerals ever since he had gone into business with the Welcomes, but in 1926–1927, he had occasion to take two very famous funeral photographs—famous then because of the persons they depicted, famous today as superb examples of Van DerZee's work.

Blanche Powell died in 1926 when she was not yet thirty. Daughter of the pastor of the great Abyssinian Baptist Church, well known in the Harlem community as a vivacious beauty, she was mourned by many. A huge funeral was held at Abyssinian Baptist Church. James was hired to photograph the event.

Back in 1914–1915, while Blanche Powell was taking piano lessons at the Toussaint Conservatory, James had done her portrait. After he had photographed her funeral from one of the upper balconies of the church, he went to his studio and developed the photograph, then redeveloped it with the earlier photograph as an insert in the top right. The effect is the apparition of a young, happy girl hovering over the proceedings, watching her earthly funeral from some other peaceful dimension.

James did not use the same technique the next year, when he photographed the funeral of Florence Mills. He could have, because he had photographed the singer previously. But he chose to use another technique. He photographed the open casket, flowers all around, from such an angle as to include a window. Then, with the aid of his etching pencil, he added lines to emphasize the rays of the sun streaming into the quiet room.

When Florence Mills died, Harlem mourned as it never had before. The singer had enjoyed great success in Europe and had

Family portrait with children at piano.

James got Rabbi Mathews to pose for this "gypsy fortune-teller" picture.

"Memories," one of the earliest and finest examples of Van DerZee's use of the multiple-image technique.

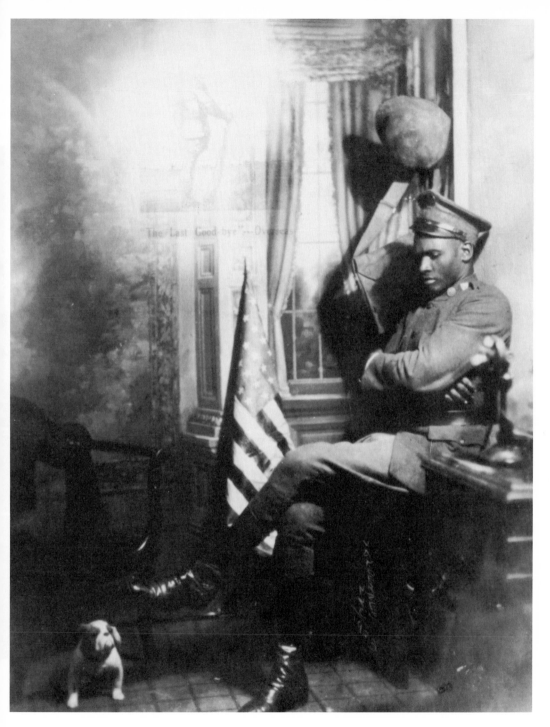

Here James superimposed a wartime cartoon on his portrait of a
soldier.

One of the "women waiting" calendar photographs.

"His Pipe," one of Van DerZee's atmospheric photographs.

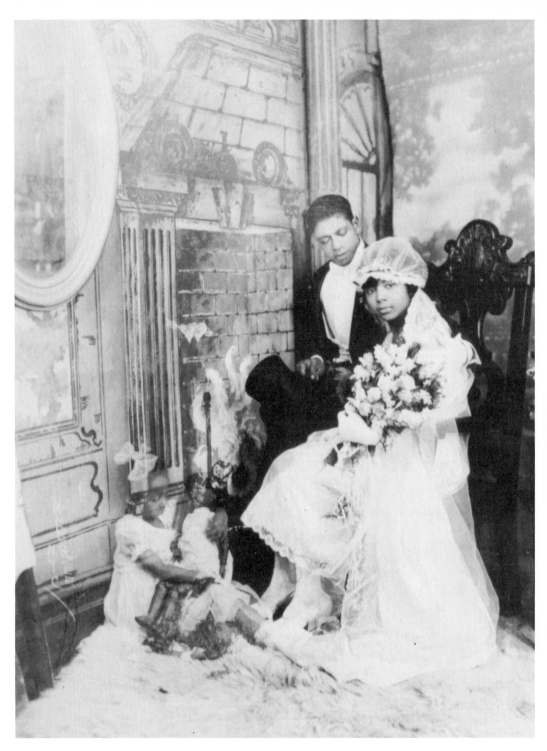

A wedding photograph, using the multiple-image technique.

Florence Mills's funeral picture. Van DerZee added the rays of light with his etching knife.

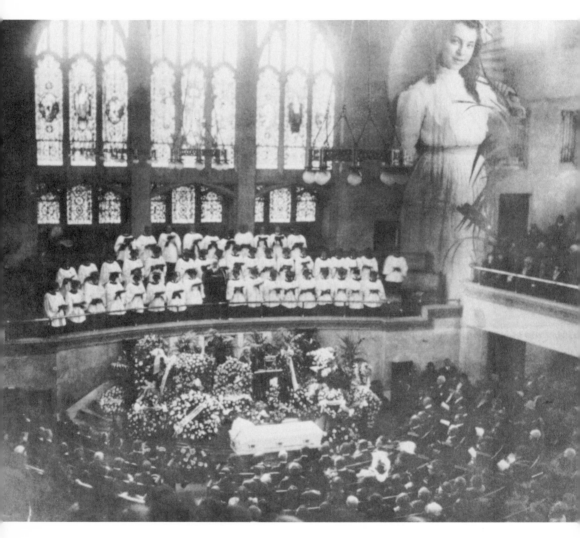

The funeral of Blanche Powell, 1926. Van DerZee superimposed the portrait of her that he had taken earlier.

returned to the United States only a few months before her untimely death. Hundreds of thousands attended her funeral, hoping to catch a last glimpse of her. The place was so crowded that James could not get in at first, so he slipped one of the ushers a twenty dollar bill and managed to gain entrance through a back door. For the rest of America, 1927 may have been the year Lindbergh made his transatlantic flight in the *Spirit of St. Louis*, but for the people of Harlem, it was the year Florence Mills died.

Even James Van DerZee, who was not in the habit of marking events, paid his own tribute to Florence Mills. "I did a funeral picture of an old man lying on the couch, and I had a newspaper in his hand. It was just the time that Florence Mills died. I noticed a headline of her death in the paper. And it just looked like he was lying there reading the paper and fell asleep.

James Van DerZee was a sentimental man. He understood how it felt to lose a loved one, for he had lost many—his father, his brother Charles, his sister Mary, his infant son Emil. In 1928, he also lost Rachel.

The July 16, 1927, issue of the New York *Age* reported:

RACHEL VANDERZEE, HIGH SCHOOL SENIOR, DIES AFTER BRIEF ILLNESS

Miss Rachel Vanderzee, 19 years of age, died in Portland, Maine, Sunday, July 10, following a brief illness. Miss Vanderzee was a senior at the Wadleigh High School and had gone to Maine to recuperate following an illness of two or three months . . . apparently recovering her strength she suffered a re-

lapse a few days before her death. Her body was accompanied to New York by her mother, Mrs. Kate L. Vanderzee of 2206 Seventh Avenue.

The late Miss Vanderzee was well known in Harlem as a basketball player and a member of the Cheerful Contributors Club, an organization of young high school girls and debutantes doing social service in Harlem.

Funeral services were conducted from the chapel of James Witherspoon, 134 West 131st Street on July 14. Interment was at Woodlawn Cemetery.

"They tell me she died of a ruptured appendix," said James Van DerZee half a century later as he surveyed the few mementos he had of his daughter other than his photographs of her—drawings she had done as a child, a newspaper clipping showing the members of the Cheerful Charity Contributors Club in 1926, Rachel's face partly concealed by a wide-brimmed hat but unquestionably a Van DerZee. The article listed Kate Van DerZee as an honorary member of the organization.

After Rachel's death he lost track of Kate. His only news of his former wife had come from Rachel during her occasional visits to the studio. Rachel's death severed the last link between them. "She eventually remarried, a man named White. I'm not certain. I never saw him. I don't remember when she died, but I did hear about it and wondered what was the cause of her death."

James had a new life now, a life that centered around Gaynella, and photography. The years 1920 to 1935, when he was aged thirty-four to forty-nine, were the peak of his photography career. Coincidentally, they were also the years of the Harlem Renaissance.

ARTIST AND PHOTOGRAPHER

James did a great deal of work for various churches. He photographed the Reverend Adam Clayton Powell, Sr., alone and with a Sunday school class at Abyssinian Baptist Church in 1925, did quite a bit of work for the Moorish Zionist Temple of the Moorish Jews, taking some wonderful photographs of Rabbi Mathews of the Temple. And, of course, he took many photographs of people and events at the Catholic churches.

There were the various civic and fraternal organizations, the Elks, the Masons (of which he was a member), the Unity Athletic and Social Club, the Loyal Men of the Hour Association, the black fraternities like Alpha Phi Alpha, the black athletic teams. In those days Harlem abounded with such organizations, for there was much civic pride in the community. James Van DerZee would record nearly all of them at one time or another.

"Christmastime and Eastertime, graduation time, confirmation time—they were very busy seasons of the year. I was almost too busy to come out of the studio. Families during the holidays—a lot of people waiting for pictures. Sometimes you'd have a lot of babies, and you'd have to take the time to get them all spruced up, expressions on all the faces, and sometimes people wouldn't want to wait too long. But other than that, I didn't have any trouble."

James Van DerZee did not have a lot of time or material to devote to purely artistic photographs. He was making his living almost solely by photography (he still taught music on the side and charged thirty dollars for twelve lessons), but he usually found ways to combine his artistic needs with his financial ones. One way was to tell a story in the context of a commissioned photograph. Another was to do calendar photographs.

"I didn't just make photographs for my own pleasure, not un-

From left: the Reverends Bolen, Brown, Powell (seated, father of the first black U.S. Congressman), and Cullen (foster father of the famous poet Countee Cullen).

Rabbi Mathews of the Moorish Zionist Temple in Harlem.

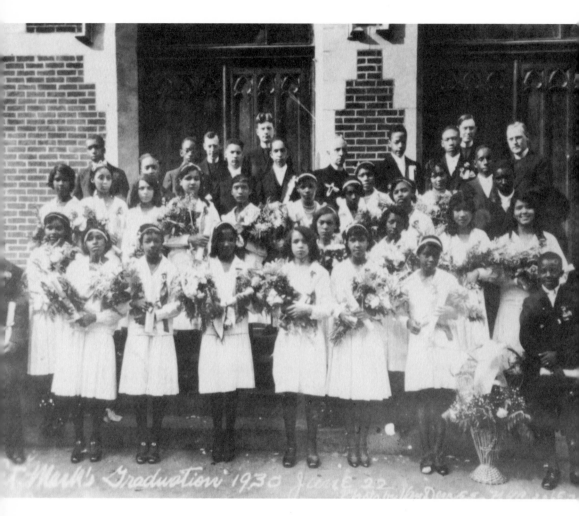

Graduation Day, St. Mark's Church School.

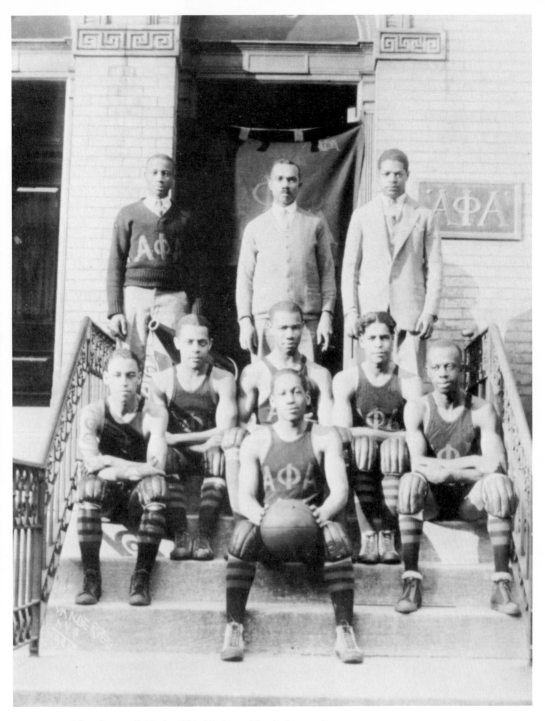

Members of Alpha Phi Alpha, a black fraternity.

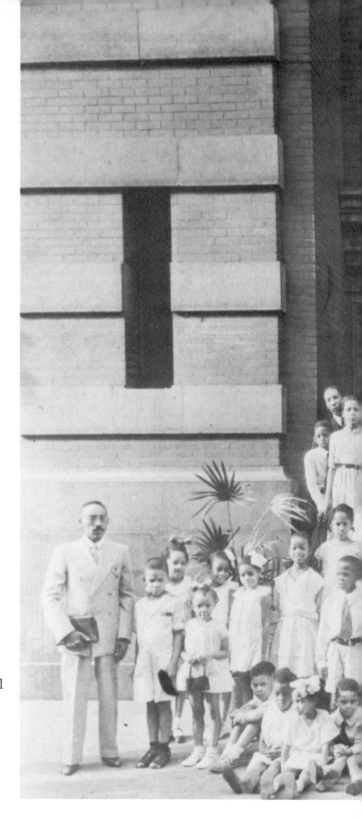

Church of God Sunday school

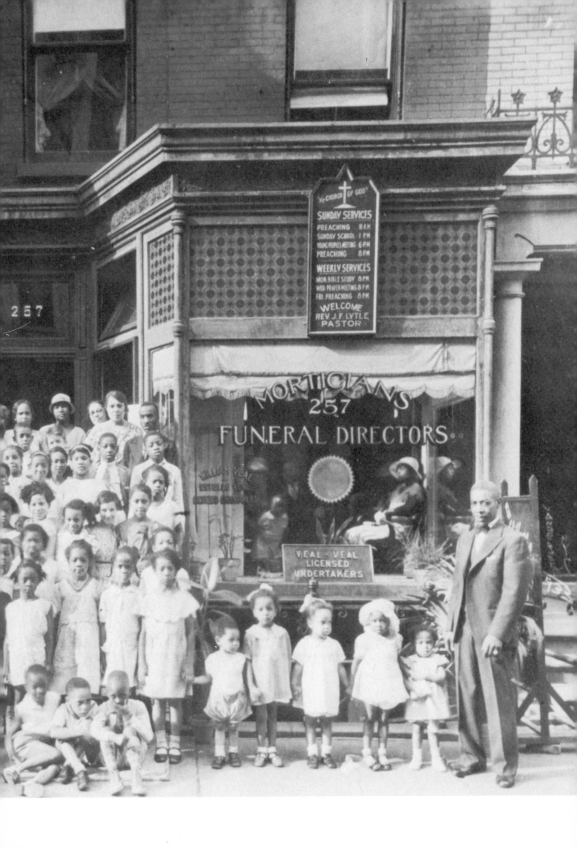

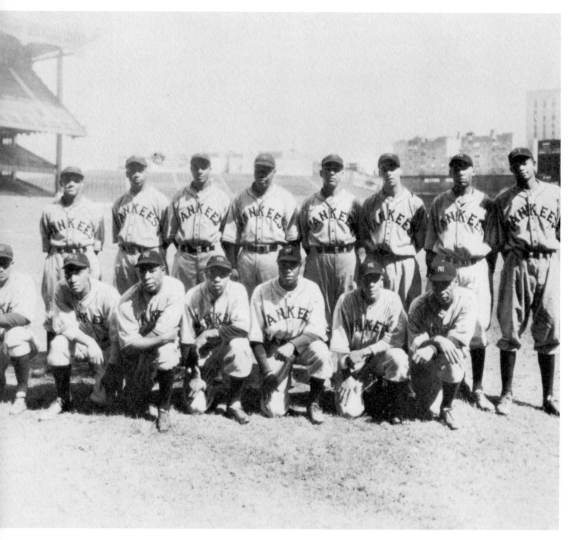

The "Black Yankees," a Negro baseball club sponsored by the New York Yankees in the days before blacks were allowed into the major leagues.

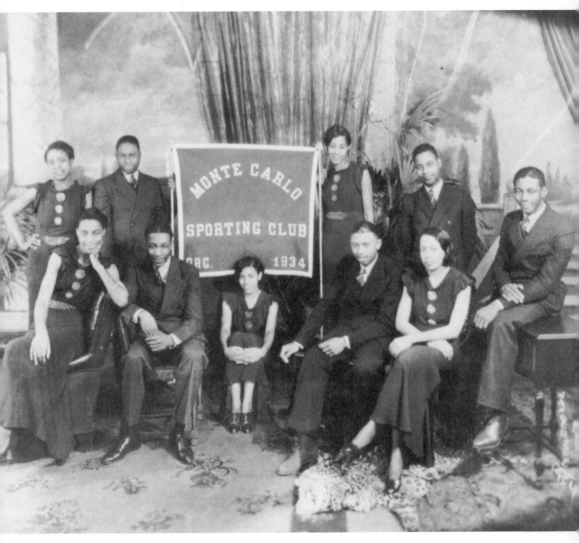

The Monte Carlo Sporting Club, with a prize from one of its hunting expeditions.

less it was something that I thought would be of use later on. I started making pictures for calendars. People would come in to have their pictures taken, and I would pose them so the picture could also be a calendar picture. If it came out well, I would give the people a couple extra pictures and get them to sign releases. I'd send the pictures to the different calendar houses. A lot of companies started making calendars of Negro subjects, and I found this very lucrative. There was a man out in Fort Worth, Texas, who wanted to do calendars of Negro subjects but he didn't know where to go and get them. He wrote to Eastman Kodak in Rochester. Eastman used to have salesmen who went around to the different studios with Kodak papers and merchandise, so they knew about me. They gave him my name and address. The calendar business was a good business."

Among the photographs James took with calendars in mind were those he described as "little home scenes." There is a series of women waiting for their husbands to come home. In one, a woman with her hand on her hip leans against a mantle on which a clock ticks away. In another, a woman sits in a chair, smoking. On the floor by the chair are a pile of dishes. There are also several milk bottles which, presumably, it is the husband's duty to take out. The clock in the background is striking eleven. The woman is holding a rolling pin and looks as if she has every intention of using it on her husband when he finally returns.

James also photographed some nudes as possible calendar subjects. He did not do many nudes, but those he did were in good taste, sensuous but neither lewd nor suggestive. On occasion he was approached about doing others that were not in such good taste.

"Sometimes there were guys who would want some nude pic-

tures made, but I told them the only kind I could make would be within the law. They would bring me some to make copies of. Copying that sort of thing was a job I didn't want. I was pretty strict on that kind of thing in those days. I liked my freedom too well."

There were such things as "girly magazines" in those days, according to James, but they were "more secluded; you couldn't go out and buy them off the newstands and all that the way you can now."

In 1928, James and Gaynella decided to incorporate their photography business, so they engaged a lawyer to draw up the necessary papers. The lawyer immediately informed them that if they wanted to incorporate they would have to change the studio's name. "He said the only ones who could use the name Guarantee were banks and trust companies, so we had to pick a new one. So I decided to name it after my wife. Her name was Gaynella, and when I met her it was Gaynella Greenlee—G.G.—so I added another G. and called it the G.G.G. Photo Studio.

"I always liked to live a somewhat secluded life, in the background. People didn't even know who James Van DerZee was, only knew that I was the 'picture-takin' man.' Most everyone called me that. The cops used to call me Michelangelo [after the famous Italian Renaissance painter]. I never put my name on the front of the store. I thought that was kind of vain. I'd put any kind of name out there except mine. Yeah, Bashful Jim, that was me. He's not so much in a crowd, but when you get him alone you'll be surprised. I put my name mostly on my work."

James Van DerZee signed and dated nearly all his negatives and prints. Signing the prints was just good business. If people

liked the work he did for others, they would come to him to have their pictures taken. But signing the negatives was the habit of an artist rather than a businessman. They were his creations and he was proud of them.

He was also in the habit of keeping his negatives and extra prints, although he had no great sense of historical or artistic mission in doing so. "They say the whole Van DerZee family were junkmen. I guess they just saved everything. Fortunately, one time I saved the right thing! But I always took a personal interest in the pictures I made. I did my best and tried to make them as good as I could, and if they were satisfactory to me, I just kept them." Over the years the growing number of glass and film negatives and prints, which would eventually total some 75,000, proved a storage problem, but James held onto them.

He did not save them indiscriminately, however. He made plenty of mistakes in the course of his work, and bad or poorly developed negatives were disposed of. "We could sell those old glass negatives at so much a pound. They used to use the glass to cut faces out for alarm clocks. Or, you could sell the glass to somebody and they'd take the emulsion off, get the silver out of the chemicals. I had one negative that I made of a person, and I was in a hurry for it to dry, so I hung it up near a gas stove that I had there, and when I went to get it the emulsion was all zig-zaggy and the face all crooked. I threw it away. But it was all so evenly melted and everything out of proportion, the way it came out, it would be very 'in' today, probably very valuable!"

7

The Later Years

"Every man needs a good woman behind him, to encourage him and to give him initiative and reason for doing what he does. It doesn't take much to satisfy a man by himself." In Gaynella, James Van DerZee had a good woman.

Theirs was a very happy marriage, though they were different in many ways. She was Catholic, he was Protestant; she was a registered Republican, he was a registered Democrat; she was forthright, he was reticent. Every so often, she would remind him that she could have gone to Hollywood to star in films for Metro-Goldwyn-Mayer; every so often, he would remind her that he had six or seven women friends who were just waiting for him to become free. And they lived happily together for over fifty years.

They never had children, although they did not make a decision not to, in James's recollection. "Instead, we had cats. *I* didn't have them—*she* had them. I like cats, too, but not the way she

did. She called them her 'babies.' I remember back when Lind-bergh made his flight, she had a kitten she called Lindy. When her favorites died, she would have them stuffed."

Gaynella called him "Bunny" or "Nanny." He called her "Baby Doll." They went to movies at the Winter Garden, on picnics and day excursions. They worked side by side at their various photo studios. "She was really on the ball and saw farther ahead than I did, because when we picked out one place she thought would make a good studio, I thought it would make a good garage! But she turned out to be right."

Over the years they operated studios at several locations: in 1925 at 100 West 135th Street; in 1930 at 2065 Seventh Avenue; in 1937 at 2077 Seventh Avenue. It was the studio at 2065 Seventh Avenue that Gaynella chose over James's objections. It had never been a garage, but it had been a Chrysler showroom. "They used to have twenty-five to thirty automobiles on display in that place. There was plenty of space for work and for storage." Most of the early moves were dictated by the need for more space—to work in and to house James's burgeoning collection of glass and film negatives and prints.

Gaynella was the subject of many of these photographs. Of all the beautiful women he photographed, "the one that impressed me most would be my wife. Because her pictures needed no re-touching. In all the different poses, there was no retouching re-quired. But I don't know *when* I took all those pictures of her!"

There is a lovely one taken in 1926—an "artistic" photograph for which Gaynella posed in a nunlike, lacy head covering. It is considered one of the best examples of Van DerZee's sensitive use of lighting, ordinary window lighting in this case. There are pho-tographs of Gaynella in middle age, still very beautiful. One pic-

ture, taken by a friend, shows James and Gaynella in their parlor in the 1930s. She holds up one of her "babies," while James looks lovingly down at her.

He was an indulgent husband. He bought her expensive gifts; every birthday and holiday he would give her a diamond ring, a broach, or some other piece of fine jewelry. She liked to buy clothes for him. "She used to buy from Weber and Heilbroner. They were quite fashionable, but I think they're out of business now. She always used to want me to have the best of everything. I'd tell her all the time to buy for herself, that I didn't need anything, but she was always more satisfied buying for me. She used to buy more things than necessary and buy ahead of time. I knew, of course, she was spending my money, but at the same time I wanted to see her dressed up and happy."

James was forty-three years old when the stock market crashed in 1929 and the Great Depression came on. By the mid-1930s, he and Gaynella had begun to feel the effects of the Depression. "I was paying $175 a month for that big studio, and I began to fall behind. The agent said it was all right, just continue to pay when I could and I wouldn't be bothered. But I noticed that on every monthly bill he kept putting down the balance past due, and I figured sooner or later someone would come along and offer him more money for the store than I was paying and it would be up to me to pay the balance or find another place.

"My wife. didn't see it that way. She'd say, 'He said it was all right.' I'd say, 'He didn't give it to you in writing. He's only the agent, you know.' I think the New York Life Insurance owned the building.

"Anyway, rents were going up in the neighborhood and people

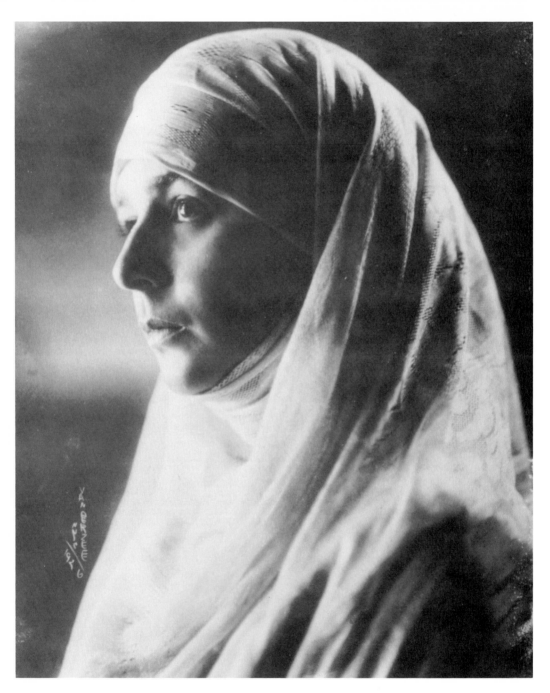

Gaynella as "nun."

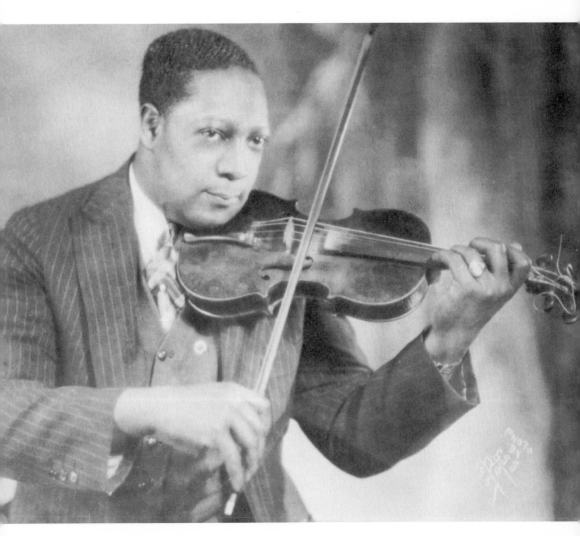

Gaynella took this photograph of James with his violin.

Anteroom of the G.G.G. Photo Studio, 1930.

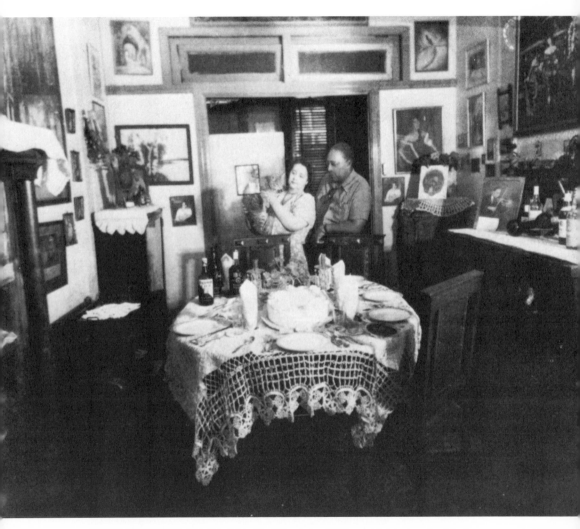

James, Gaynella, and one of Gaynella's "babies," about 1930. A friend
took the picture.

One afternoon in the 1920s, Van DerZee thinks, he and Gaynella took a ride out to the Sheepshead Bay area of Brooklyn to visit the grave of Quentin Roosevelt. Gaynella took this photograph of James lighting his pipe.

In 1928, James and Gaynella and some friends went on an outing to
Poughkeepsie, New York. On the way back, they had a flat tire on the
149th Street Bridge. While a friend changed the tire, Gaynella took
this picture of James.

were moving out. I knew when my lease expired my rent would go up, too, and when I found out it would go up to $225 a month, I knew we wouldn't be able to pay it. In the meantime, a store in the same block became vacant. It was smaller, but it was only $80 a month, so I took it on my own to rent that place. She didn't like it, but I could see the changing times.

"So we moved in there, and it wasn't long before that landlord began to get difficult, asking for more money. So I decided that as soon as we could find a place where we could live and do business, too, we'd take it. When this place became vacant over on Lenox Avenue, I made arrangements."

They moved to the brownstone at 272 Lenox Avenue in 1942. James was in his middle fifties. They would remain there for twenty-six years, and it would be their last studio.

Despite their problems meeting their monthly rent payments, the Van DerZees were never destitute during the Depression, and so they were luckier than many other people in Harlem. James remembers seeing the people standing on bread lines and selling apples on street corners. He remembers a young man who lived on ten-cent frankfurters and the crowds in a restaurant owned by a man named Jack Rose who served an ample dish of corned beef hash for fifteen cents. He and Gaynella never went hungry, and he was never out of work. Although portraits became a luxury that some Harlemites could ill-afford during those years, "I always kept busy. There were so many different types of pictures: chauffeur license, hack license, copies, and enlargements. Outside of the other portrait work, Easter was still a busy day. More family groups at Easter than any other time in the whole year. People would keep coming back over the years. I'd make pictures of them as children; they'd grow up and come back to have me

THE LATER YEARS

make their wedding pictures, and after that pictures of their own children.

James had friends and acquaintances who lost their jobs or were evicted from their homes or whose incomes were not enough to live on. He helped them out whenever he could. "This boy who could only afford frankfurters, I helped him quite a good deal. If people were having a hard time, I'd give them some money to help tide them over. All except for this lady friend. She always needed money, even though she had a big house out in Englewood, New Jersey, a Cadillac, furs, and jewelry. I used to call her the 'mink toy.' She used to call me 'Daddy Van.'

"I remember one time she came by driving this big Cadillac of hers. 'Daddy Van,' she said, 'give me some money to buy gasoline for my car. I've only got a twenty dollar bill and I don't want to break it.' I told her, 'You drive your Cadillac with a twenty dollar bill in your pocket, and you ask *me* to buy you some gas, and I'm *walking* and only got ten dollars in my pocket? You better go ahead and break it or give it to me and I'll break it for you!' "

In 1939, James photographed Ben Gilmore, a white man who was from Lenox and who was J.P. Morgan's chauffeur. "While he was in the studio, he suddenly said, 'I forgot. I guess I better go lock the car because the old man's got a $2,000 mink blanket in there that he puts over his knees. I wouldn't want that to be missing when I get back.' So he went out and brought in the blanket."

Evidence of such luxury as a Cadillac and a mink blanket would have caused other men to be bitter, but James did not resent the wealthy. Nor did he share the bitterness some blacks felt about how Harlemites were hit harder by the Depression—last hired, first fired—than other New Yorkers were. Adam Clayton

Powell, Jr., began writing a newspaper column in the New York *Amsterdam News* in 1936, exhorting blacks to acquire more political awareness, and in 1937, he started a campaign that began by picketing and boycotting stores on 125th Street in Harlem to force them to hire blacks. Eventually it led to city-wide boycotts of major municipal and private organizations that did not hire blacks. "There were quite a few that were very active in the demonstration work, trying to get jobs in these different shops, which they eventually succeeded in doing, but we didn't participate in the demonstrations."

For a time in the 1930s and 1940s the two were active in politics. James, the Democrat, and Gaynella, the Republican, were both on political committees, and for some years polling places were located in their studios. "We had two studios on Seventh Avenue where the polling places were each year. We had the polling place when we had the big place, and that was in the thirties. And then we moved in that same block, to a smaller place, and we also had the polling place there." Both voted for Franklin D. Roosevelt.

"When Pearl Harbor came, I couldn't believe it for quite a while. But it turned out to be a reality, and I wondered how it could have happened with all our secret servicemen and all, how the alert men that we had were taken unawares like that. They sank so many ships before they were stopped."

As in the earlier war, Van DerZee had no strong feelings about the conflict. "I had nothing to do with it, and I figured I wouldn't be drafted because of my age. All these wars are supposed to be wars to end the wars, but they're still fighting all over the world now, in different places."

James could have joined a photographer friend who had gone

THE LATER YEARS

to work for the government in Washington, D.C., and who wrote asking him to go, too. "It was blueprint work and that sort of thing. I passed the government exam, but I didn't want to leave the city. They were offering $3,200.00, and I was making that much myself about every six months in the city. Besides, he said there was a lot of segregation down there."

United States entry into the war meant more business for James Van DerZee. Quite conveniently, the loading point for a bus from Harlem out to Picatinny Air Force Base in New Jersey was located right in front of the G.G.G. Studio at 272 Lenox Avenue. Many soldiers had their photographs taken by James before boarding the bus, and other soldiers, sailors, and their families visited James throughout the war.

One such visit led to a remarkable coincidence. A group of white people dropped in one day, on their way to the doctor next door. A young man in the party was about to go into the air force and they wanted a group picture. Jokingly, James suggested that the young man might take Gaynella, who loved airplane rides, for a short ride to Lenox. The name Lenox sparked the interest of a woman in the group, who asked if he had known a particular family in Lenox. James went to a filing cabinet and pulled out a letter written from the Hotel Eton in Rome in 1902. "Dear Jimmy: It was very sweet of you to write me and send me those lovely photographs. I think you deserve a good deal of credit for taking such awfully good ones. . . ."

James's astonished client cried, "That letter was written by my mother! Before I was born."

James chuckled to himself. "Quite a coincidence, to come to a little dump in Harlem and find a letter from her own mother."

"And then there was Hiroshima. The atomic bomb was devel-

oped and they tried it out over there in Japan. Why, that kind of ended things. A lot of innocent people lost their lives on that account, but I don't know what would have happened if they hadn't dropped that bomb. Those people were very determined fighters. They would get in a one-way plane and sacrifice their own lives, direct that thing right at a ship or something else. So it's pretty hard when you're up against an enemy of that kind, who fights with that determination, and you are fighting just because you have to, and don't know why you're fighting, fighting a lot of people you don't know anything about, or never seen, nor heard about."

By the time the war ended on August 14, 1945, James Van DerZee was fifty-nine years old. Everyone, it seemed, had a camera. "It made a scarcity in the demand for studio work. I found it was pretty tough to make a living at it." So James modified his business. Though he continued to do portrait work and work for local churches and schools, and to make passport photographs and photographs for licenses of one sort or another, he also started doing more advertising in church publications, offering to copy old photographs. Most of these publications, like *Sacred Heart Magazine*, had an international readership.

"I was getting letters from all over—Alaska, Gold Coast of Africa, Trinidad, Puerto Rico, Panama, even all the way from Russia. They'd send pictures to be enlarged and copied. But the business from the States was much better. Postage to the other countries was higher, and foreign customers would write a lot of letters before they'd send any money. Sometimes, they'd want you to do a sample for nothing."

Despite the problems, James continued to make a living at photography, and Gaynella made extra money by renting out the

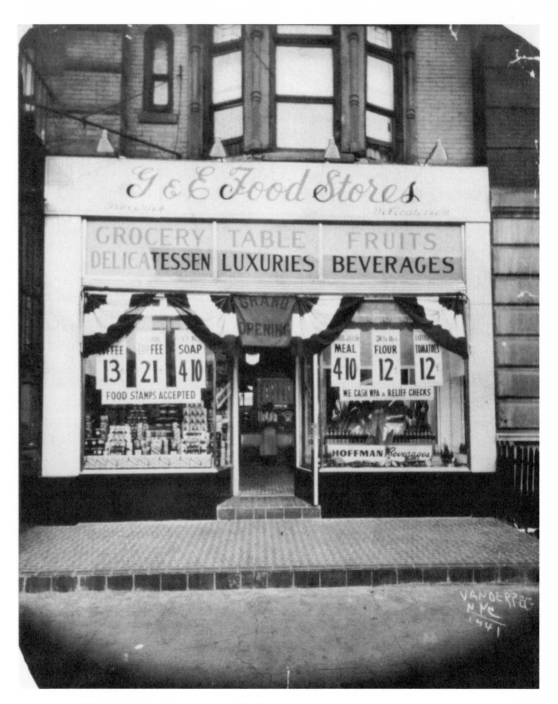

A Harlem storefront during the Depression.

Van DerZee's last studio, at 272 Lenox Avenue.

A display advertising Van DerZee's work in corner drugstore window.

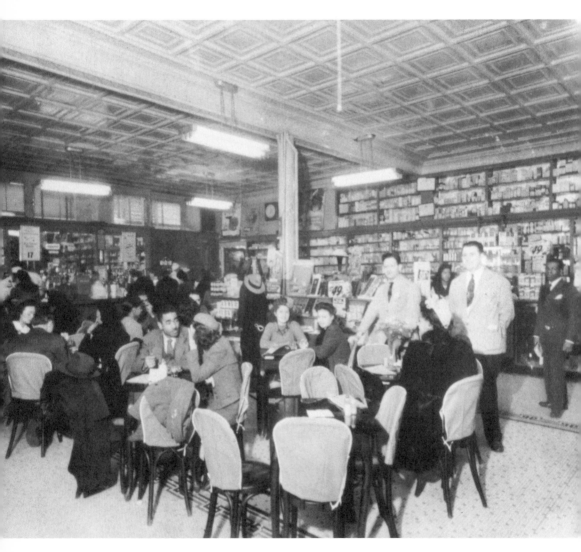

Interior, drugstore.

James Van DerZee with Jim Smith, one of their boarders.

James Van DerZee's mother.

extra rooms at 272 Lenox Avenue. There were some seven spare rooms on the second and third floors of the brownstone building.

"She had one big room on the top floor for $16.75; another one in the back, $15.75; one below that, $12.75; another one in front, $18.75; two other ones, $12.75; another one, $10.75; and a small hall bedroom, $10.75. She was getting all that money, but she was paying the rent. I was buying the oil and the supplies for the studio and the food for the house and paying the other bills.

Whatever was left over from their respective businesses was theirs to do with as they wished. James would make plans to buy more equipment or to improve the house, but more often than not he would wind up lending it to less fortunate friends. Gaynella's weakness seemed to be buying things. "She had an account at Macy's, an account at Bloomingdale's, Lord and Taylor's, and she didn't buy just one of something, she would buy two or three. Wrap them up and put them away—for a rainy day, I guess. So if I'd get a few dollars I'd rush off to the bank with them." He saved his money rather than ask her to save hers. He loved her, after all, and wanted her to be happy. As the years passed Gaynella became not just the woman he loved but the only loved one he really had.

Out in Jamaica, Queens, his mother had died one week before her seventy-fifth birthday. "That was a shock, because she hadn't been sick. My sister called me up and said that my mother wasn't feeling good and when was I coming over. I decided I'd better go right away. So after we closed up the studio we went out there, but by the time we arrived she'd been dead two or three hours. She died of shortness of breath, I guess, just ran out of breath. We were at 2077 Seventh Avenue then, I think. That must have been in the early forties."

Walter also died, but not before he had been honored as the oldest employee of the Loft Candy Company in Long Island City, where he had been employed since 1909, when the company was located at 54 Barclay Street in Manhattan. "He had family troubles at the time of his death, because he was living with us." Then Ernest Welcome died, a man who had had so many dreams. He had run a domestic help service and a real estate business as well as a conservatory. He had invented several machines that turned human excrement into fertilizer. "I sold stock for him for awhile. I don't think he ever sold the patents; or, if he sold them, whether they were ever used. The company never turned out to be as big as he'd intended it to be."

After her husband's death, James's sister Jennie continued to operate both the Conservatory and the real estate business, but she devoted most of her time to teaching. James would visit frequently. "I made a great many pictures of her students. Whenever I think of Jennie, I think of children; whenever I think of children, I think of Jennie. She always had the house and the yard full of children. She'd teach them painting and drawing and music and wouldn't charge any fee; she was just interested in their learning."

Jennie died of cancer in 1956. Several local black newspapers printed obituaries, because Ernest Welcome had been important in the New York black community, as she herself had been. Among other things, the obituaries mentioned the Dunbar Realty Company and her work with children at the Toussaint Conservatory. For a black woman of her time, she had been highly succcessful.

"Her death was another sad occasion for me," James recalls. "She went to the hospital expecting to come out, to go back home.

But they said she was full of cancer or something. I had an autopsy done because I couldn't understand, and I don't believe it yet, how she could be so full of cancer. I had to close up the place, and I kept thinking about that yard so full of children. . . ."

The trouble with getting old is that one loses so much—not just eyesight or agility, but family and friends. Often, one even outlives one's roots, the things that always seemed solid and indestructible. Around 1930, James had visited Lenox, and so much was still there. There were the three houses in a row, the stable, and the old abandoned mill. His Osterhout aunts and great-aunt Lena Egbert, though old now, were still baking and taking in laundry and quick to remember the same events and people James remembered. Within a decade or so, all those things and people that just naturally went together were torn apart.

A highway was to be put through the property. The state would pay the family, and the money would be divided among them. But James did not want the money. He wanted the family enclave to remain intact. "I wrote letters protesting it, but they were of no avail. I received a letter that said everybody in the family had signed the agreement but *me*, and I was holding up the distribution of the money. So one of my aunts came down to the city and told me where I should sign the paper, and I signed the paper. That was the end of the Van DerZee and Osterhout estate. The money was divided up—the family was all figured into it—and we kids got about fifty or sixty dollars apiece."

James Van DerZee did not return again to Lenox. Lena Egbert died, and both Mattie and Estelle Osterhaut were living in a nursing home in the town at the time of Jennie Welcome's death; but they, too, are now dead.

The old sawmill on the Van DerZee property in Lenox.

One of James's great-aunts, standing before her home; the sign advertises the bakery the sisters operated.

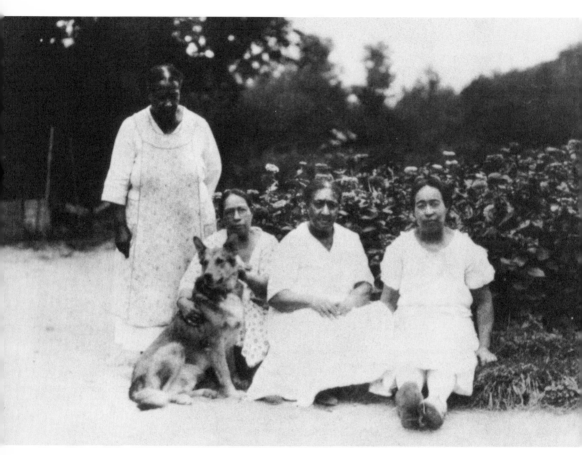

The Osterhout sisters, Lenox, 1930.

THE LATER YEARS

In the late 1960s, James had some correspondence with David Dana, president of the Lenox Library and one of the old Lenox Danas. Dana informed him that his grandparents' house was still standing and that the barn and stables were still there. The stables were probably in better condition than the house, Dana reported, since it looked as if the house was infested with termites.

With most of his family gone and his birthplace the property of the state of Massachusetts, James clung to Gaynella, and together they struggled to make a decent living as the popularity of home photography made James's studio business increasingly obsolete. Changes in their Harlem neighborhood made living in dignity more and more difficult.

The repeal of prohibition and the Depression had brought about the untimely end of the Harlem Renaissance. Many observers felt it would have ended pretty soon anyway, for it depended greatly on whites. As Langston Hughes put it, "How could a large and enthusiastic number of people be crazy about Negroes forever?" Even the blacks who had directly benefited from the Renaissance had done so at a price. The writers, artists, musicians, and singers had been forced to perform or produce a certain type of material in order to get white recognition and support. Langston Hughes noted that the books by blacks that received acclaim during that time were those that dealt with "exotic themes," themes with which the white audience was largely unfamiliar. One could write about slavery and Southern plantations, blacks in urban "sporting" districts where bars and brothels operated, about illegitimate children, knife fights, lynchings and sex, but if a black writer decided to write about a middle-class black family, or even a poor one that tried to advance in the

world, the white benefactors and benefactresses and the white publishers were not interested. Orchestra leaders like Duke Ellington found that they were encouraged by whites as long as their music had jungle rhythms and jungle titles, but if they tried to play a classical piece, white audiences received them coldly. Many creative black people who got their first recognition during the Harlem Renaissance had begun to feel like puppets anyway; but the end of the Renaissance and what came after it were a shock, still.

After liquor was made legal in December, 1933, the speakeasies lost much of their attraction, and their gangster owners lost a whole industry. While liquor had been outlawed, the various criminal gangs had all made enough money bootlegging to coexist with one another quite peacefully. The "crime pie" was big enough for all of them to have a piece. When Prohibition ended, that pie shrank dramatically, and the gangs began fighting over control of drugs, prostitution, and gambling. Several incidents of gangland violence occurred in Harlem, and some innocent people were killed. Harlem became a dangerous place.

Meanwhile, the Depression had begun. Many Harlemites lost their jobs. Ragged-looking people stood on street corners. Lines to the free soup kitchens extended for blocks. Sadness and despair seemed to hang over Harlem—it was no longer a gay place. The night clubs that had catered to whites moved downtown or closed altogether. Black writers found that their manuscripts were rejected, that their patrons were no longer interested in them. Black actors and black musicians could not find jobs. The "New Negro" was dead, because he had only existed in white imaginations in the first place, and now whites had turned their attention to other things.

THE LATER YEARS

World War II came along to end the Depression. Jobless young men joined the armed forces, and war industries employed older men and many women. But after the war, there was another economic slump in the country and another depression in Harlem. Once again, blacks lost their jobs in greater numbers than whites and once again there was hunger. Harlem's population had grown during the war, for thousands of Southern blacks had come to northern industrial centers to work. To make room for them, landlords had divided their buildings into even smaller apartments (for which they demanded high rents), but still there was overcrowding.

By now the luxury buildings that had originally been built in Harlem were nearly half a century old, and most had lost all vestiges of grandeur. The streets were full of potholes, and city garbage collection was haphazard. But white city leaders and the white population in general cared little about Harlem or its people. All through the 1950s and early 1960s the population of Harlem grew, and there was no relief. Harlemites were refused homes and apartments in white neighborhoods. Their schools were not given adequate supplies, and black children were not taught the skills they needed to get good jobs. The pressure and resentment built, and in the middle 1960s Harlem exploded.

There were riots in the summer of 1964. It was ten years after the U.S. Supreme Court decision outlawing segregated schools. Since that time, many changes had taken place in the South. The Civil Rights movement had brought about an end to much segregation in the states below the Mason-Dixon line. But few changes had occurred in the North. Blacks still lived in ghettos such as Harlem had become, still found that only menial, low-paying jobs were open to them. Angry and bitter, one hot summer night some

Harlemites started to take out their frustration on their own community. For peace-loving people in Harlem, it was a time of terror, an assault on their neighborhoods. James and Gaynella found themselves right in the middle of it.

"You could hear window glasses crash every now and then. We managed to save the store next to us, the grocery store. But there were other stores that lost everything to the looters. There were people passing by with all kinds of things. Once they'd cleaned out the furniture and clothing stores, they hit the grocery stores. They cleaned them out completely, even the soda bottles, because they could get a five-cent refund for them. A guy came by a few days later wearing a suit of clothes that didn't fit him very well. He said it was his 'riot suit'—got it at the time of the riot. They had all kinds of jokes like that, but I couldn't very well see their point of view. I know I wouldn't have any part of it."

A Civil Rights Act came on the heels of the violence in Harlem and in black sections of other northern cities. Designed to eliminate discrimination in public places based on race, creed, color, or national origin, it basically outlawed segregation in the United States. In James Van DerZee's opinion, "That did a lot of good, but it also did a lot of harm in a way of speaking. Before that Act we used to be able to get some very nice roomers. After the Civil Rights Act came in, why, a great many of the high-class roomers that we had went to the big hotels downtown . . . and looked like all we could get was reliefers and small-time people. These reliefers would come and burn the lights all day long, cook in the rooms. They were a different class of people."

"Reliefers," or tenants on welfare, did little to improve the condition of the house, which was old and in need of repair. But Gaynella could hardly keep up the monthly payments and James's

income was not enough for improvements. One night the tenant above James's bedroom went berserk and began burning newspapers on the floor of his room. Fortunately, the damage was not extensive.

The incidence of fires on the block was increasing. The neighborhood became progressively more dangerous as James and Gaynella grew older and more defenseless. "It got so it was pretty hard to do business where you had to keep the door locked until you could see who wanted to come in." There were several robberies. "One time they broke into the back, another time through the skylight in the roof. Another time they moved the brass lamp off the front of the building and the brass off the rails out front; and the last time they just threw a rock through the front door and came on in." Neither of them was harmed during those robberies. It was in the days before the elderly had become targets for violence. "Nowadays, they mutilate your body and try to put you out of commission."

Though they despaired of the changes in their neighborhood, they did not think of moving. They were elderly and did not relish the idea of leaving the home in which they had lived for over twenty years, of uprooting themselves from familiar things. Their financial situation was such they they could not afford to move, and even if they could have, it would have been difficult to sell the home.

In 1967, James was contacted by researchers hired by the Metropolitan Museum of Art to find photographs for the upcoming "Harlem on My Mind" exhibition. After they saw the quality and quantity of his work, they assured him that many of his photographs would be used in the show and that he would be paid for their use. But final selection and payment were a long way off,

and James did not realize what might be the outcome of the inclusion of his work in a major show at the Metropolitan. Had he known, he might have responded differently to the events that were shortly to change his and Gaynella's lives.

Early in 1968, Gaynella stopped making the monthly mortgage payments on the house at 272 Lenox Avenue. Eleven months before, the Van DerZees had decided they were wasting the money they paid in rent and that they should buy the house. Gaynella had decided no bank would give them a mortgage because they were elderly. So she had obtained a mortgage from a loan shark, making the arrangements by telephone. The monthly payments were so high that she assumed they included taxes and other fees. It was a struggle to make the payments. One by one, the diamond rings and other pieces of jewelry they had given each other over the years were taken to local pawn shops. Nearly a year later, Gaynella realized taxes and other fees were not included in her mortgage payments, they were extra. Faced with these additional bills, and unable to cope either with them or with her sense of betrayal, she told her husband that she was not going to pay any more mortgage.

"And so it was up to me." Eighty-two-year-old James Van Der-Zee was willing to assume the payments, figuring he could manage somehow, but Gaynella's decision had been so abrupt that he did not have time to make arrangements. "Instead of giving me time to get a second mortgage, she immediately stopped paying, so the man who was holding the mortgage started foreclosure on the place. And then I went to my bank, the Freedom Bank, and they gave me commitment papers for a second mortgage. I gave them to an ex-judge named Mr. Stout, who I thought was a friend of mine, to arrange the closing, and he wound up with the title of

the place in his name. And after he got title to the place, the referee's deed, he started sending people by the house to look at the place. Every time we refused to let somebody look through the place he'd serve us with a seventy-two hour eviction notice, and that upset my wife, kind of brought on a nervous break-down."

A woman lawyer who owned the building next door bought the Van DerZee's home. James told her she was buying "stolen property" and explained what had happened, but she was not sympathetic. All she was interested in was having the house. The next thing James and Gaynella knew, a marshall and deputies were in their home. The men were under orders to get them out.

"I was downstairs trying to protect the studio and the things down there. She was upstairs, and I knew she would fight to the last man. When I went upstairs I saw they had her tied up in a chair, getting ready to send her to Harlem Hospital. I figured she'd be safe there. I should have had them all locked up, for fraud or something, but it was as if my own hands were tied.

"The marshal searched the place. He found and turned over to me about eighteen hundred dollars in travelers checks and some uncashed Social Security checks. He had me sign for them. He also gave me twenty one-dollar bills. All the rest of the cash he kept for himself. She had about seven or eight thousand dollars hidden in the place. Oh, what a rotten deal! But there are laws in this universe, and I figured that marshal would get his proper payment at the right time."

Gaynella was soon released from Harlem Hospital, and community workers temporarily placed the couple in the Hotel Concord Plaza. But the city was only supposed to pay for the temporary housing of victims of fire and similar disasters. An

elderly couple who had lost their home because of failure to pay the mortgage were not classified by the city bureaucracy as disaster victims. The Van DerZees would have to pay for their own housing. Community workers showed them several apartments. James chose one on West Ninety-fourth Street. "I knew it was too small, but I thought it was the best neighborhood."

Most of their belongings were put into storage, for not much of it would fit in the one-bedroom apartment. But at least they had a place of their own once more, and James hoped that Gaynella would cheer up. "I really thought she would recuperate, but she was never straight after we were evicted. She couldn't understand why I took her out of a fourteen-room house and put her in a two-room apartment. I was never able to explain to her about the changing times and so forth. It was impossible to make her see it."

The next eight years were not happy ones. Gaynella had lost the most important quality of life, hope, and James was unable to revive it in her. "She didn't take an interest in anything. She didn't seem to want to fix up the apartment. She used to follow those morning TV programs, and for quite a while she followed the funnies in the paper; but she got so she lost all interest.

"She used to have a good memory. Then all of a sudden she couldn't remember one day from the other, couldn't remember much of anything. I think that annoyed her a lot. She kind of lost her hearing, lost her eyesight.

"I made a picture of her sitting in the rocking chair one day. She didn't know when I took it. She never saw that. She thought I was just fiddling around with the camera."

In the spring of 1976, Gaynella fell and broke her hip. James took her to St. Luke's Hospital. "She had no regular doctor. They say when you have Medicaid and get to be a certain age, they

just don't bother with you. One time when I went to visit her, she pleaded with me to take her home. Oh, I wanted to. I'd tell her, 'The babies want to know why you don't come home. The pictures on the wall don't smile. Our whole house is blue. They want you and only you. But I miss you most of all.' But she didn't really want to get well. I could see her fading like a rose."

Gaynella Van DerZee died that May, just a few days before James's ninetieth birthday, and thus ended a partnership that had endured for close to sixty years. The last years had not been happy ones, but James would not think of those times when Gaynella was not herself. He would remember the years before.

"I loved that woman. When she was young, she was beautiful, and she became beautiful for me afterwards because I loved her. Through all the thick and thin years and the in-between years, deeper than the deepest oceans, a love taller than the tallest tree, that's the way it was for me. And I think she left me with a song that will never end."

8

The "Discovery" of James Van DerZee

When Reginald McGhee was hired by the Metropolitan Museum of Art as a researcher for its upcoming "Harlem on My Mind" exhibit, he had never heard of James Van DerZee. He knew only that he was supposed to find photographs of Harlem and its people that would help balance the single image of Harlem that too many Americans had. The object of the exhibit was to show that there had always been pride and talent and beauty in Harlem, and that its contributions to New York City were many and valuable. During the course of his research, McGhee visited several photography studios in Harlem. He heard about an elderly photographer who still operated a studio at 272 Lenox Avenue. In December, 1967, he paid a visit to that man.

James obliged the young man by showing him some photographs. McGhee was impressed with the quality of the work, and when he learned of the quantity of material in Van DerZee's col-

lection, he could hardly contain his excitement. The representatives he sent were allowed to look through dozens of prints and negatives and to select whatever they wanted from what was a veritable gold mine of historical and artistic documents.

For his part, though he was perfectly willing to give his time and help to the young McGhee and his associates, James Van DerZee was not excited. McGhee was not the first person in the recent past to express interest in his work. Several years before, _Esquire_ had carried two full pages of photographs of the front of his studio and its photo display. Other magazines had photographed the G.G.G. Studio. Individuals and institutions had asked for his photographs for publication and for exhibition. He'd always been helpful, even generous with his work. For his efforts, he'd received a credit line here and there but no money, and often his photographs had never been returned. So, he was kind to the people from the Metropolitan, but he did not feel enthusiastic about the idea of the "Harlem on My Mind" exhibit. He thought it was "just another advertising stunt." Had he known beforehand the kind of publicity the exhibit would engender, he later admitted, he would have offered the people from the Museum a far better selection of photographs than he did.

But what a selection it was. Although the "Harlem on My Mind" exhibit, which opened in 1968, comprised hundreds of photographs from a variety of sources, private as well as commercial, James Van DerZee was the largest single contributor to the show. Many of his group portraits of clubs and fraternal organizations were used, his photographs of Marcus Garvey and his movement, his portraits of Daddy Grace and Judge Ferdinand Q. Morton, his scenes of Harlem life. The exhibit even included the 1930 photograph of Gaynella and him in their home.

JAMES VAN DERZEE

Many of the photographs in the exhibit were huge, which amused James. "They were eighteen feet high and fifty feet long, some of them. Everybody's *life size* in the pictures. I'd never seen such big pictures. But they were just as clear and sharp, all the details and the brilliancy were still there. It was due to the fact that they'd been made on large-size film." He was very pleased about how well his work looked in the exhibit.

Other viewers were deeply impressed not only with the subject matter but with the technique, the craftsmanship. Who was this photographer, James Van DerZee? people asked. And when his telephone started ringing, and visitors began coming, and the check for the photographs used in the show arrived from the Metropolitan, James Van DerZee started asking the same question himself.

"The Metropolitan Museum of Art paid me *one thousand three hundred and sixty-five dollars*, just for pictures they had used, that I'd already been paid for by the clients, and that didn't earn that much for me probably in the whole year I was making them! Then, they begin publishing these books. Two thousand dollars advance royalties from Grove Press. And seven hundred and seventy-five dollars for the pictures used in the 'Harlem on My Mind' book. So, the picture business began to get very interesting!"

He went back through his collection, "took a review of a whole lot of them myself to see what is in them that everyone seems to see." He concluded that his old photographs were somehow new to a new generation. That was the only way he could explain why people were suddenly treating him "like the only photographer in the country."

All of a sudden the modest man who had lived his life in rela-

tive obscurity was so feted and honored that he hardly knew what to make of it. He was given the Award of Merit from the Photographers Forum, honorary doctorates from Mount Holyoke College and Seton Hall University. He was elected to membership in the National Geographic Society and was made a Fellow for Life of the Metropolitan Museum of Art, which acquired sixty-six of his photographs for its permanent collection in 1970. He has been the subject of retrospective exhibitions at the Witkin Gallery and the Alternative Center for International Arts, Inc., in New York, and of magazine articles too numerous to count. He has been featured on television programs, has lectured at the International Center of Photography, and been a judge for Time-Life, Inc., photographic exhibits. He even received a letter informing him that he had been selected for inclusion in a book called *Community Leaders, 1976–1977*, and unaware that such "who's who" books proliferate to the point of being a racket, duly filled out the biographical questionnaire, only to find out later that he would have to pay for a copy. "Yeah, they have all kinds of ways of blowing you up and knocking you down and charging you for it."

Nevertheless, the publishers of *Community Leaders* are to be commended for including James Van DerZee. Few other books do—neither the histories of photography, nor the cultural histories of Harlem, nor the collective biographies of blacks in the arts. It is likely, however, that the oversight will be corrected in future books and in later editions of books already published. James Van DerZee is no longer an obscure black photographer.

He was presented the annual Paul Robeson Award from the Duke Ellington School of Fine Arts in Washington, D.C. He traveled there by train. "They had engaged a parlor car for me. I

JAMES VAN DERZEE

drank ginger ale and Scotch all the way down, and they had a limousine there to take me to a very fine hotel. They engaged rooms for me at $140 a day. There was a great big reception room with a color TV and a telephone. In my bedroom was a great, king-sized bed, fifteen-foot ceiling, drapes at the window, another color TV in there, and a telephone beside the bed. And in the bathroom, so many towels—expect they thought I'd walk out with some of those towels, but I fooled them. I didn't have very much time to spend there anyhow. They told me the TV men would be there the next day to make recordings at ten o'clock. So I had to prepare for them."

In May, 1977, he received an honorary degree in Pittsburgh. "I thought it was going to be a degree in photography. When they told me I was going to get a doctor's degree I wanted to know if I'd be able to perform abortions. They said, oh no, not *that* kind of doctor, but if I'd been doing it before, why, I probably could continue. I said to hell with it, there's no money in it. They said it was a Doctor of *Laws*. That's even better than an M.D.

"They told me the last guy who had received that degree lived about two years afterward. I said, '*Now* you tell me!' But the place was all decorated and it was too late to back out. So I figured maybe I'd get an extension."

To receive the degree in Pittsburgh, James Van DerZee took his first plane ride—under protest. He looked out the window and all he could see were clouds. "This window's too small for this piece of humanity to get through," he thought worriedly. And when the plane rocked a bit he whispered, "Keep it straight, keep it straight." Having made the trip safely, he was not anxious to repeat the experience, although he decided it was quite an accomplishment at the age of ninety.

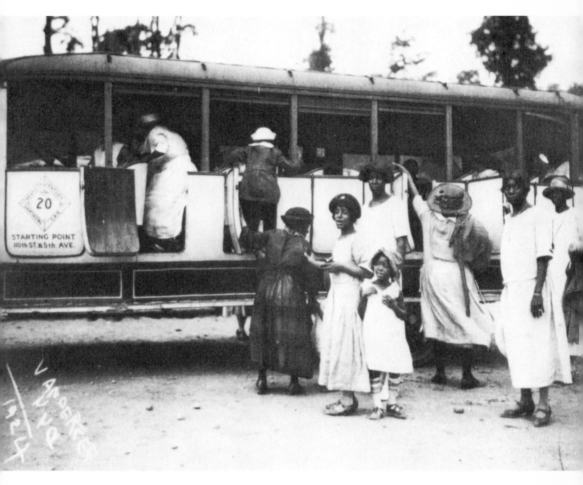

One of the sightseeing buses Ernest Welcome operated in the early 1920s.

First grade, St. Mark's Church School.

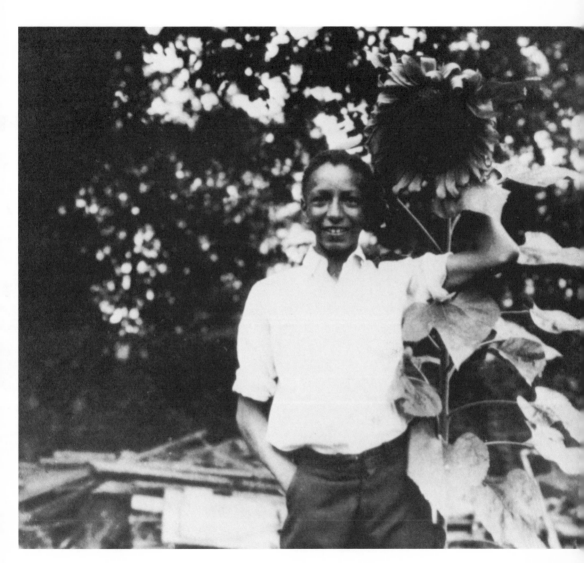

Eddie Walker, Van DerZee's second cousin, Lenox, 1930s.

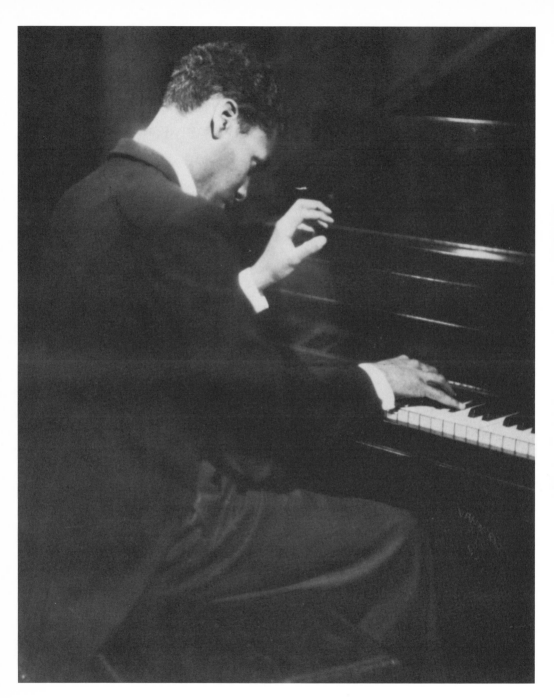

Piano player.

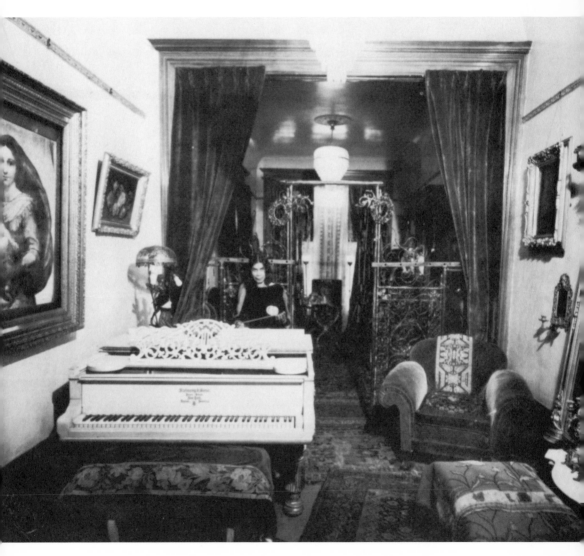

The woman in this picture worked for the owner of this house on 122nd
Street. When the employer died, the woman inherited the house.

The bedroom of the house on 122nd Street.

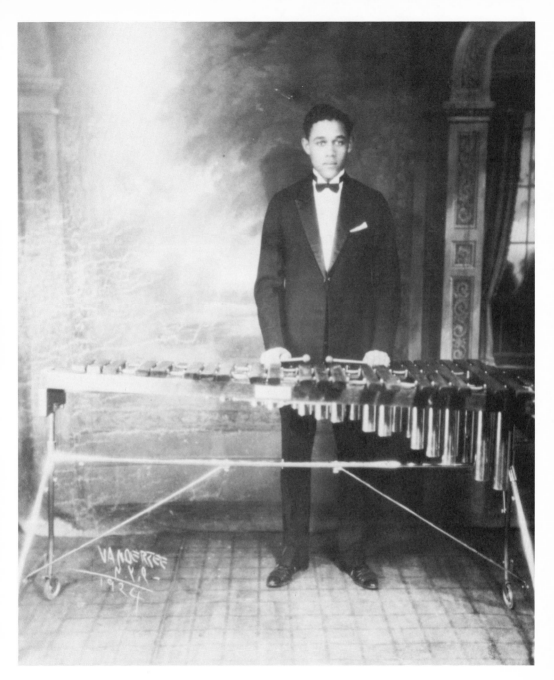

Alonzo Bellous, a musician.

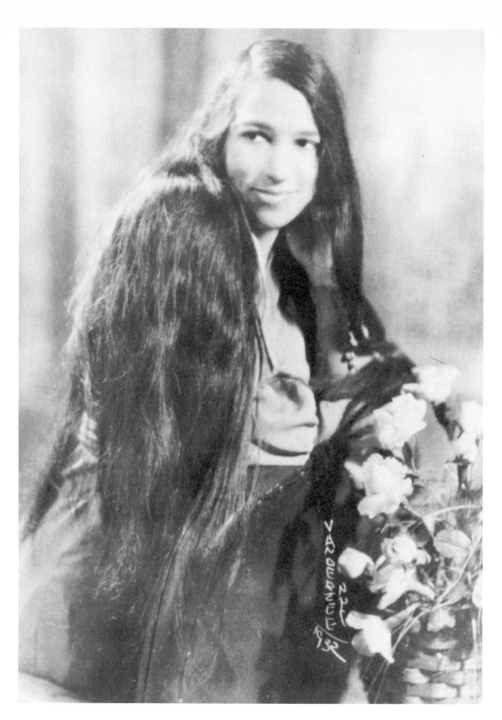

A Harlem beauty.

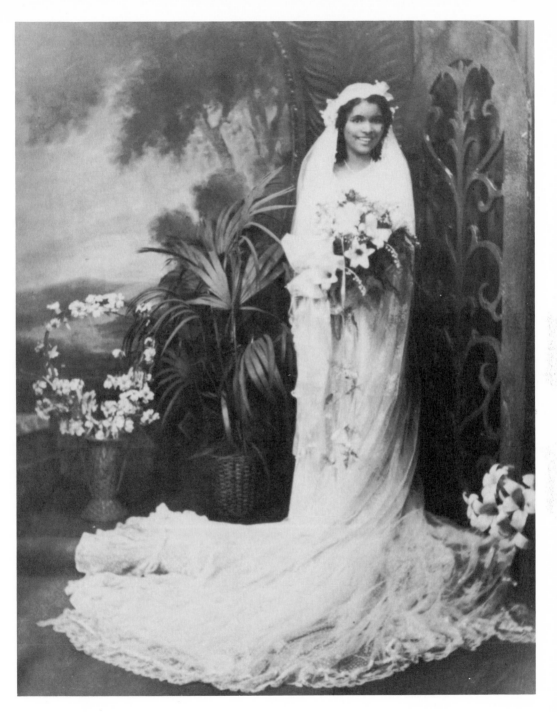

A lovely bride in front of a painted studio backdrop.

Overleaf: St. Mary's Convent School

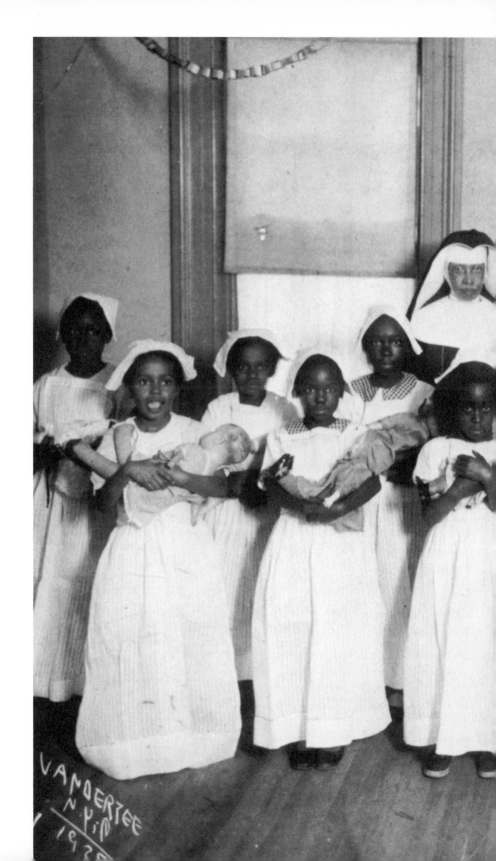

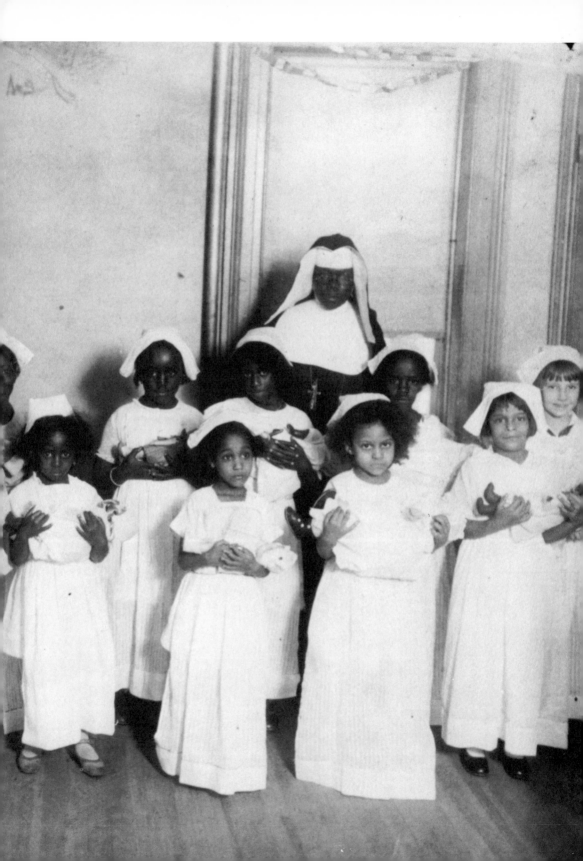

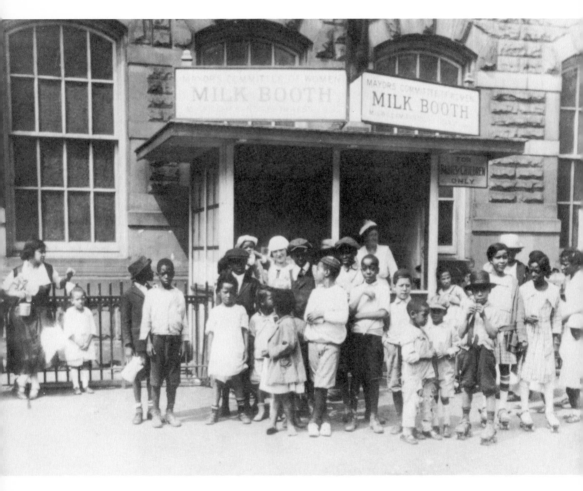

Harlem children during the Depression.

THE "DISCOVERY" OF JAMES VAN DERZEE

How he wished Gaynella had been there to share that plane ride and some of the other happy experiences that attended his discovery. If he had been discovered a couple of years earlier, he and Gaynella might not have been evicted from their home, Gaynella might not have suffered her breakdown, their last years together might have been happier ones. James Van DerZee has never been given to mourning what might have been, but once in awhile, when asked how he felt about being discovered, he would remark sadly, "It was too much, too late."

The remark was usually a reference to Gaynella. The apartment on West Ninety-fourth Street was full of memories of her. Like her husband, she was a great saver, but also a meticulous wrapper of the things she saved. Once his storage bill was paid and he had access to the belongings they had been forced to store after the eviction, he had to be extremely careful not to throw away what looked like mere wads of tissue paper. Inevitably, there was something wrapped up in them, an old pair of spectacles or a piece of jewelry. And there were so many photographs of her. It seemed as if every pile of negatives or prints contained at least a few, and finding them would cause him to pause and remember the occasion of the photograph and how she was then.

"I have friends. Twenty-five or thirty ladies formed a club named the Friends of James Van DerZee. They paid off my storage bill, had different parties to raise money. You'd be surprised how many cards I get from them. But at the same time, it seems like nothing without her. I know I have to reshape my life. That's a pretty hard thing to do, to start out at this age, to start all over again. I'm used to seeing a woman around the house. It doesn't seem natural not to, but I don't know anybody I want to marry. And I don't want to be like the ninety-year-old man who

married the eighty-nine-year-old woman and who spent the first
three days of his honeymoon trying to get out of the limousine!"

Sometimes, the remark "too much, too late" was a reference to
his career as a photographer. "Well, I'm sorry it didn't happen
earlier in life. The inspiration would have given me encourage-
ment to have done even better than I did. At one time we had a
lot of pictures around the place here, and they didn't attract as
much attention as a few do now. Now, they write me from Ger-
many, from France, from Sweden, for pictures, pictures, pictures.

"And the prices they get for some of my pictures! One maga-
zine said that one Van DerZee print sold for five hundred and
seventy-five dollars! It was some picture of a mother and a child,
but I don't even know what picture that could have been, now. I
made so many pictures. But these Madison Avenue dealers are
getting more for some pictures than I made in a whole month.

"And the pictures of myself that other people take. Every time
I go someplace, somebody takes my picture and sends me a copy.
I have more pictures of myself than I ever thought of having.
There's a woman photographer for *Esquire* magazine who took a
lot of pictures of me one time. And later on, somebody showed me
a clipping, an advertisement in *Vogue* magazine: one 10-by-12-
inch picture of James Van DerZee, one hundred and twenty-five
dollars. *Clark Gable* couldn't get that much for his portrait."

James was glad "somebody's able to get something out of all of
this." He was also pleased to know that there is a new interest in
early photographs and photographers, and that his discovery may
have helped spur this interest. Some have said that his discovery
was instrumental in the search for other previously unknown
photographers, but that would be difficult to prove. Rarely can a

vogue be traced to a specific source. Rather, it is usually the result of a combination of factors. But it is probable that the "Harlem on My Mind" show helped: the realization that an obscure photographer in Harlem had thousands of prints and negatives of beautiful quality led researchers to hope that there were others like him, men and women whose work, lying forgotten in attics and cellars and storage vaults, was a treasury of history and artistry.

It is to be hoped that the treasure that is the life's work of James Van DerZee will be preserved.

"After the 'Harlem on My Mind' show broke up, there were several offers to buy out the collection. The First National City Bank offered $175,000, but McGhee said it would be better to set up the Institute ourselves." In 1969, Reginald McGhee and Charles Inniss founded the James Van DerZee Institute. It was housed originally at 103 East 125th Street. "That was a bad street. The police were there all the time." Because the Institute could not pay its rent, its curators were forced to sell some of the prints. That is how James Van DerZee learned what kinds of prices his photographs commanded from Madison Avenue dealers. In 1976, through a grant from the Helena Rubinstein Foundation, the Institute moved to the Metropolitan Museum of Art for two years. Then, it moved to the Studio Museum in Harlem at 2033 Fifth Avenue. At this writing, however, it is not certain that the collection will be permanently housed there, either. Many of the thousands of prints and negatives that James Van DerZee preserved so carefully are still without a permanent home, and lie uncatalogued in a warehouse.

James Van DerZee hopes that new generations will have the

opportunity to see and appreciate the work that he considers real photography. He finds modern photography somewhat hard to understand.

"All the photographs in these books these people give me—I can't understand the object of making them. Pictures of four marked-up walls, people with clothes hanging off them. They seem to me to show a lot of misery and a lot of negligence. Photographers today don't do any retouching. I always try to depict people at their best, but nowadays photographers seem to believe in 'tell it as it is.' "

At the same time, James Van DerZee has nothing but admiration for those who have contributed to the technical development of photography. To a man who started with apparatus hardly more advanced than the old camera obscura, the changes in photographic equipment during his lifetime are astounding. Although they put a lot of studios out of business, he appreciates the influence of such cameras as Instamatics (which he now uses) and Polaroids (which he has never used). "With the first Polaroids a lot of people had bad judgment. They'd overdevelop and overtime them. But then they began making cameras that people couldn't make mistakes with. Now they have these cameras that take the picture and it develops itself. It's remarkable the amount of brains that some of these people must have. This unsophisticated and retarded individual with a dwarfed intellect mournfully remembers that arithmetic was too complicated for me!"

But this veteran photographer feels he still has a few things to show the brainy people he so admires. When asked what he considers his greatest achievement in life, he responds shortly, "I haven't done it yet," and goes on to describe his efforts to develop

a two-lens camera. "I call these cameras today 'one-eye' cameras. Have you ever tried closing one eye and picking up something? Two eyes give you a better perspective. So would two lenses. I was about to send my design to some patent attorneys, but I discovered they weren't patent attorneys. All they did was sell inventions, and I wondered how would they protect their clientele."

At times, he speaks of going back to photography, of getting a more spacious apartment across the hall and setting up a studio there, where he would do only portrait work. When asked if he misses photography, he is equivocal. "I do and I don't. It was interesting work at one time, until they came out with all these Afros and so forth. But I'd like to get back to it, just to be doing something, I guess."

His days are comfortable. A woman named Maude comes in to clean, and he receives one hot meal a day from a local "meal on wheels" program. When Gaynella was alive, two meals were delivered. After she died, someone from the program called to say James was entitled to only one meal now and should not be receiving two. James informed the caller, "I eat one at noontime, the other one at night."

He has an income outside his Social Security check, but it is not a steady one. When a royalty check comes in, or a fee for the purchase of one of his photographs, he feels rich, but he is likely to give much of that money to a needy friend.

"It's pretty hard for me to say no. A lot of people get disgusted with me. They're trying to help me and I turn around and help somebody else. Case of the blind leading the blind, I guess. But there was this boy who lost his house—he went through practically the same thing as I did—and this other friend who lost his

job. If I have a few dollars that I don't need for a few days and they have immediate need, why, I take their matter more seriously than mine. Sometimes they reciprocate and other times they don't, and sometimes I get the money back from somebody else.

"There was a woman I helped move to a decent place. The house she was living in was deteriorating. The elevator was shut down, the landlord was not paying the light bill, so the power company shut off the hall lights. So I gave this woman seventy-five dollars and that night some people came and bought one hundred dollars worth of pictures. So I got my money back the same day.

"They say happiness is a sort of perfume. You can't pour it on somebody else without getting a few drops on yourself. Everybody says I should get more exercise, but do you know any better exercise that bending down to help somebody up?"

James Van DerZee has problems with his legs and feet. He walks with a cane and relinquishes his comfortable bedroom slippers only when he has to go to receive some award or honor. He spends most of his time in his little one-bedroom apartment, opening the mail that arrives daily from all over the world, receiving telephone calls and visitors.

He needs little encouragement to get out his boxes of photographs and clippings, and on occasion, and usually on request, he will sit down at his piano, apologizing that both it and he are now somewhat of tune, and play one of his original compositions, like "My Broken Rosary." He is loath to play the violin for company. "You really have to put something into the violin. With the paino, you can sit down and express any mood you feel and the tones come out just as strong and profound. But with the violin, if you

don't put a real effort into it, why you get such a squeaky, squawky tone that even the cats come up and say, 'Meow.'"

Invariably, whether he is prompted or not, he will talk about the days when he was contemplating a career in music or when he first started out in photography. Some of the stories he has related again and again, because again and again visitors ask him the same questions.

"I don't mind. It breaks the monotony. But I keep being reminded of the past, and sometimes I don't know whether I'm living in the past, present, or future."

Whether talking about the past, present, or future, he has little bitterness. About the past: "If I had life to live over again, I probably would have done about the same, but maybe in a different way, or at a different time. You don't forget what you learn from experience. Comes a time when you have certain regrets, I guess, but I don't know. Maybe in that respect I've got a short memory. I've made mistakes like everybody else, but to be able to see your own mistakes, I guess, is some accomplishment. I don't have any regrets, really, other than the loss of the home. [In the fall of 1977, New York State Attorney General Louis Lefkowitz offered to help James redress his grievances regarding 272 Lenox Avenue, but James declined. "Gaynella had died, so there was no use. I didn't want the place back."]

"Even the loss of the home didn't anger me too much because so much was happening at the same time—the 'Harlem on My Mind' show was coming on and I was getting huge checks from them like I'd never received before. And then the books were being published. When something bad happens, you have to look for the good that comes out of it."

JAMES VAN DERZEE

About the present: "Well, I don't complain a great deal. I always try to live somewhat like the sundial, only recording the sunshiny hours. Something bad happens, as soon as it's over, goodnight! Forget it!"

About the future: "I'd like to live to be a hundred. There's still a lot to learn. You never stop learning, and you never stop trying to figure out what life is all about. You spend half your life trying to understand old folks and then you spend the other half trying to understand young folks. When you're small, you got small troubles. When you're big, you got big troubles. Seems like there's one thing after another. Only reason I'm hanging around is to see what is going to happen next!"

Index

INDEX

INDEX